IMAGES
of America

CAMP BOWIE
BOULEVARD

Pugilists, sponsored and trained by Young Men's Christian Association coaches at one of the installations at Camp Bowie, approach the camera ready to punch as tent frameworks go up behind them on their temporary turf west of Fort Worth. The 36th Division of the American Expeditionary Forces trained at the camp from 1917 through 1919. The US Army included boxing in its training program; after a supply of gloves arrived one Friday in January 1918, one hundred officers and enlisted men paired off in front of division headquarters in view of what was then named Arlington Heights Boulevard. A *Fort Worth Star-Telegram* reporter noted, "The men . . . were more keen to spar than the instructors desired and had to be cautioned frequently from trying to rap each other, though the temptation was great." Reformers of the period proclaimed boxing to be a good way to prepare men for combat and bayonet fighting. Post-Armistice, veteran officers who directed military training corps introduced intercollegiate boxing in the United States for building character as well as for physical fitness. (Courtesy of the Kautz Family YMCA Archive, Special Collections and Rare Books, the University of Minnesota.)

On the Cover: The Buehrig and Gudat families purchased the Spider Vine Garden Café, at 4516 Camp Bowie Boulevard, in the mid-1930s. Edmund F. "Dutch" Buehrig left the management of the Pig Stand at West Seventh and Foch Streets, determined to have his own eatery, and he formed a partnership with his brother-in-law, Dennis J. Gudat. On duty are, from left to right, Ervin Witt, Elmer McCaslin, Bill Snow, Kirby Duke, Ed Randolph, Price ?, Louise Quinn, Kate Dawn (the future Mrs. Dennis Gudat), Irene Slate, Dennis J. Gudat, and Edmund F. Buehrig. "It took almost two years to turn a profit, but it did turn out very well for both families," Dennis's son, Phillip Gudat, wrote. Dennis usually took the night shift so he could work on his 94-acre farm by day. Romeo and Charles Hughes, brothers from the nearby African American community of Lake Como, were Spider Vine cooks; later, Romeo opened a grocery store along Horne Street. (Courtesy of Phillip Gudat.)

IMAGES
of America

CAMP BOWIE BOULEVARD

Juliet George

ARCADIA
PUBLISHING

Copyright © 2013 by Juliet George
ISBN 978-1-4671-3049-3

Published by Arcadia Publishing
Charleston, South Carolina

Printed in the United States of America

Library of Congress Control Number: 2013937875

For all general information, please contact Arcadia Publishing:
Telephone 843-853-2070
Fax 843-853-0044
E-mail sales@arcadiapublishing.com
For customer service and orders:
Toll-Free 1-888-313-2665

Visit us on the Internet at www.arcadiapublishing.com

For Coleman Woods Smith

Contents

Acknowledgments		6
Introduction		7
1.	Making Way for a Streetcar Suburb: Chamberlin Arlington Heights	9
2.	The First Mile or So: A Bridge, a Park, Marvelous Machines	19
3.	Cantonment and Commemoration: All Over the Map	25
4.	Bungalow Boomers: Post–World War I Arlington Heights	41
5.	Perennial Centennial: A Zone of Muses and Museums	75
6.	Ridglea Has Everything: The Next Grand Plan	97
7.	Renaissance and Reinvention: Reconciling Old and New	117
Selected Bibliography		127

Acknowledgments

What an honor—and a pleasure—to collaborate with people who value and share history! This narrated collection represents great generosity of time and spirit on the part of many. It also represents a labor of love. I hope all who helped make this volume possible see their names here and know how much their contributions are appreciated.

Heartfelt thanks go to Judy Alter, Sam Austin, Logan Baker, Gregory Ball, Scott Grant Barker, Kathy Broyles, Kathleen Bruton, Sally Hill Bruton, Sumter Bruton, James Buehrig, Wayman Buehrig, Patsy Luther Cantrell, Caroline Willett Carson, Liz Casso, Pete Charlton, Cathleen Cook, Earl Cox, Debra Crumbie, Robert Crumbie, Katherine Cunningham, Gerard Daily, C. Jane Dees, Dorothy Paddock Dixson, Gregory Dow, Ben Eastman Jr., Gordon Eastman, Beth Phillips Engelhardt, Earl Freeman, Robert Freeman, Jonathan Frembling, William Joseph Gabriel, Wayne George, Olive Ellis Greenwald, Gayle B. Gordon, Patrick P. Gordon Jr., James Gudat, Phillip Gudat, Ben Guttery, Ward Hall, Paula Harris, Jana Hill, Dalton Hoffman, Charles Holder, Barney B. Holland, Roy Housewright, Tom James, Phillip K. Joe, Jabari Jones, Thomas Kane, Kevin Keim, Tom Kellam, Bud Kennedy, Glenn Killman, Wini Klein, Susan Allen Kline, Velma Koontz, George Kruzick, Kendal Smith Lake, David Lamb, Nancy Lamb, Diane Barnes Lidell, Mark Lidell, Debbie Linsley Liles, Bob Lukeman, Kristilee Wilson Marks, Alice Roberta McAllister, Kaye Buck McDermott, Michael S. McDermott, Quentin McGown VII, Blair Elizabeth Jolley McGroaarty, Wayne Meadlin, Steve Murrin, Mike Nichols, Bob Norris, Vicki Barnes Norris, Dave Oliphant, Daphne Dixson O'Neal, Danny Owens, Jim Palmer, Christina Patoski, Joe Nick Patoski, David Pearson, Jackye Anderson Plummer, Robert Lee Powell, Alan Price, Susan Murrin Pritchett, Bill Ramsey, Sandi Ramsey, Patricia Kane Ray, Stylle Read, Lenna Hughes Recer, Marjorie Johnson Reid, Bob Rominger, Ollie Rominger, Bernd Schnerzinger, Betty Shenkle, Tiffany Shureman, Elizabeth Howard Simmons, Barbara Smith, Coleman W. Smith, Dan Smith, Nancy Sparrow, Cathy Spitzenberger, Ann Stahl, Peter Stahl, Dink Starns, Cynthia Stevens, Steven Stuckey, Patricia Virasin Tainter, Lonn Taylor, Karl Thibodeaux, William J. Trotter, Estrus Tucker, Ted Tucker, Ned Van Zandt, Phil Vinson, Bubba Voigt, Julie Litsey Voigt, Barvo Walker, Elise Walker, Ed Wallace, Sylvia Belle George Walls, Alice Roberta McCart Walters, Pierce Watters, Shelia Webb, Wyatt Webb, Dottie Dixson Wellman, David Wharton, Byrd Williams IV, Earl Stephen Wilson, Steve Wilson, David Woo, Elizabeth H. Wood, Richard Wood, Dawn Youngblood, and Robert Zaslavsky.

INTRODUCTION

Boulevards were imported into the United States as a part of the park movement of the late nineteenth century and were a major part of the formal vocabulary of the city beautiful movement of the early twentieth century. . . . They were often part and parcel of land development promotions. . . . Usually built well in advance of the residences that were to line them, they were intended to give a sense of good things to come to the prospective well-to-do homeowner.

—Allan B. Jacobs, Elizabeth MacDonald, and Yodan Rofé
The Boulevard Book: History, Evolution, Design of Multiway Boulevards

Chroniclers of thoroughfares must reach back and forth in time, as well as west and east or north and south along the route, in pursuit of icons and stories. In the case of Camp Bowie Boulevard in Fort Worth, Texas, progression and acceleration of change, both great and small, vary with the section and the era. Although 21st-century urban developers perceive three distinct sections, there is an inevitable blurring of culture and commerce at the boundaries—a bit of overlap.

At the end of the 19th century, a Denver-based real estate investment firm led by an Englishman converted part of Weatherford Road into a widened boulevard with a streetcar track, leading prospects to the projected suburb. Arlington Heights Boulevard served as the conduit to Chamberlin Arlington Heights, a 2,000-acre sprawl of prairie about two miles west of downtown Fort Worth.

Between the Clear Fork of the Trinity River and present-day University Drive, a city park formally opened in 1892 and flourished; a driving club built an all-purpose track that drew crowds; and an automobile manufacturer established an assembly plant in the early 1900s. Residences and small factories materialized.

War preparations tore up the Arlington Heights section in 1917. Tents, shacks, remount depots, hospitals, and more were added to the landscape. After the signing of the Armistice and a massive mustering out, the last of the 36th Division of the American Expeditionary Forces departed in 1919, leaving a legacy of utility connections and paved streets. Part of the route was renamed Camp Bowie Boulevard, with the section from the river to Burleson Street (later University Drive) becoming an extension of West Seventh Street. Fraternal, religious, commercial, and educational leaders commissioned buildings along the route that would later gain landmark status. Homes with boulevard addresses (almost extinct by the early 21st century after waves of encroaching business zonings) framed the lives of several generations of families.

A national good-roads movement and a pathfinding committee determined that the boulevard should be part of a cardinal road to the west, allowing it to gain status and importance as a stretch of the Bankhead Highway in the 1920s. That national route, reaching from Washington, DC, to San Diego, California, became known as the "Broadway of America." The boulevard officially joined US Highway 80 in 1926.

Beginning in the mid-1930s, love of celebrations and the arts began transforming a family farm tract on the south side of the boulevard into a cultural district. Fort Worth gained three internationally acclaimed art museums bordering on Camp Bowie Boulevard.

By the second decade of the 21st century, the boulevard bisected a built environment of modernity and history. Ventures such as Museum Place brought a wall of glass to the street's edge. A 1951 movie palace in Ridglea reopened after a history-loving individual bought it and commissioned the architect son of its longtime projectionist to restore the building as a performing arts venue. A beloved neighborhood bakery moved into a former Presbyterian church building; bartenders mixed intoxicating elixirs in an English-cottage bungalow; and condominium dwellers moved into high-ceilinged digs inside a massive structure that once held Montgomery Ward catalog orders. A utilitarian post office designed by a prestigious Philadelphia architecture firm arose at the eastern gateway to Camp Bowie Boulevard with a sculpture of tornado-bent billboard standards and an

ominous mural featuring the familiar storm-defying mission statement of mail carriers, asserting the recent impact of a *force majeure*. Nearby sign-toppers bearing a stylized twister silhouette bring a sense of grim humor and community resiliency.

The search for captured scenes from the past can seem endless, and not all sought-for "holy grails" are found. There would be no photograph, for example, of the Scotch whisky–marketing clipper ship that called out to an adventurous boy in the early 1960s. James Gudat spent his early childhood years in a small, gray frame asbestos-clad house trimmed in white, within a triangle of Arlington Heights bounded by the East-West Expressway (Interstate 30), Horne Street, and Camp Bowie Boulevard. "I was always getting out of the back yard and wandering around the busy roads, much to the dismay of my parents," Gudat recalled. "In full view of our swing set, there was a fascinating billboard for Cutty Sark . . . a huge ship that rocked back and forth, slowly. It creaked 24-7, just like an old ship must have, and if there had been a way for a six-year-old to get up there, I would have."

Where are photographs of the monkey speedway that Kansas's "device king," Charles Wallace Parker, installed at Joyland, an amusement park for Camp Bowie's soldier boys? Does an image still await discovery of the ephemeral, yellow bulb–illuminated watermelon garden on the parking lot of Clyde Eddins's supermarket at the Arch Adams corner, as seen on sultry but magical 1950s nights before home air-conditioning? Where is a photograph of the Jim Crow–era sign on a tourist court at the Horne Street entrance to the Lake Como community, a grim reminder of long years of segregation? These and other images might have gone unnoticed, forgotten in a dresser drawer or scrapbook, or as a file item in an untapped archive. Even so, when the time came to stop chasing after treasures, an overabundance of collected materials made for difficult choices. Lingering over some subjects meant neglecting others. Given more time, one could produce an encyclopedic album with many more pages than are allowed here.

Glimpses of life along Camp Bowie Boulevard, from river fork to traffic circle, from long ago to recent, appear on and between the covers of this book. The reader, also a time traveler, becomes a boulevardier.

One

Making Way for a Streetcar Suburb
Chamberlin Arlington Heights

The car stable is the terminus of all the railway connections, to-wit the little dinky-dumpy, prancing, pitching trolley cars imported to this bowler town from the metropolitan manufacturing seaport city of Hillsboro, as witness the legend, long ago painted . . . while a quarter of a mile from it down a hill and southward, to which a road bordered on one side by a row of neglected-looking little trees, and treed-at lay a half dozen separated little sentinels on the other, is the only life-showing settlement in the "clearing."

—G.B.
"Fort Worth's West Suburb Arlington Heights, Where the Fresh Breezes Blow. A City That Did Not Materialize. Watering Plan Which Now Serves Horses and Cattle."
Fort Worth Morning Register, August 27, 1899

In the early 1890s, Humphrey Barker Chamberlin installed an electric transport lifeline to his new namesake suburb west of Fort Worth. Passengers on a trolley crossed over a new bridge, connected to Arlington Heights Boulevard west of the Trinity River's Clear Fork, and chugged across prairie land to reach Chamberlin Arlington Heights. There, they found an opulent hotel, a demonstration mansion, a lake, a pavilion, a pump house, and a tower filled with artesian water.

Other men had envisioned development of that acreage west of the city, but it was a Briton with grand designs and imperial outreach who took it off their hands just long enough to start in earnest. Chamberlin experienced dramatic failure in the wake of the 1893 silver panic. Defeated, he left the United States and started over in his native country. The Fort Worth venture stalled, and his successors—despite enthusiastic promotional efforts—made slow progress. Nevertheless, community life had begun.

The trolley to and from Arlington Heights Boulevard cut across the undeveloped but not quite lone prairie, carrying new suburbanites toward their homes and visitors to the hotel and the lake (both located off the boulevard). Near the western shore of Lake Como, the trolley looped and began its journey back to Fort Worth. On some nights, passengers reported hearing the cries of wolves. (Courtesy of the History, Genealogy, and Archives Unit, Fort Worth Public Library.)

According to Tony L. Burgess, environmental scientist at Texas Christian University, the vegetation scene in this contemporary photograph would also characterize the ground surface of pre-development Arlington Heights: "a dense stand of Little Bluestem Grass (*Schyzacrium scoparium*) on the Fort Worth Prairie. It is late autumn, and most of the fuzzy seeds have dropped, and the stems have assumed the reddish-copper hue that will tint grassy bands along the prairie slopes during winter." (Photograph by David Williams, TCU.)

10

Alfred W. Chamberlin signed this 1890 plat map of a portion of Chamberlin Arlington Heights. The suburb would expand with other filings. Chamberlin brothers Humphrey, Alfred, and Frederic worked together from their Denver headquarters, but Humphrey and Alfred also rented prominent street-level office space in the new Land Title Block building in downtown Fort Worth prior to the launch of Chamberlin Arlington Heights. Henry W. Tallant, former Denver Mint employee and Chamberlin's right-hand man, stayed in Texas, lived with his wife, Sallie, in the first mansion, and oversaw construction of the bridge, hotel landscaping, and more. (Courtesy of Alice Roberta McCart Walters and Roberta E. McAllister; photograph by Bob Lukeman.)

In an undated flyer or magazine page, Chamberlin appealed to investors and took the rustic out of Fort Worth. (Courtesy of Dalton Hoffman.)

11

OPEN EVERY DAY IN THE YEAR

Fort Worth's New Hotel.

YE ARLINGTON INN

Sample Rooms for Commercial Men in Connection with the Inn.

Ye Arlington Inn, Chamberlin's grand hotel, appeared on the back cover of a promotional World's Columbian Exposition picture booklet. The fair opened in Chicago on May 1, 1893. Chamberlin's financial disaster was announced on July 10. Served by the streetcar, the hotel stood a few blocks north of the boulevard at the present intersection of Merrick Street and Crestline Road. (Courtesy of Dalton Hoffman.)

The peripatetic Humphrey Barker Chamberlin began life in Market Rasen, Lancashire, England; was raised there and in the city of Manchester; and came with his parents and siblings to the United States in 1853. Before calculating launches for elegant suburbs, he had been a Civil War telegrapher, druggist, Bible-verse handbook editor, Brooklyn YMCA director, boot and shoe company partner, investor in a railroad line and a stove foundry, church benefactor, and a leader of the Denver Chamber of Commerce and of the national YMCA. Before his fall, Chamberlin and his family lived in an elegant Denver home designed by Robert Sawers Roeschlaub, architect of that city's opera house, Trinity Methodist Episcopal Church, and the Chamberlin Observatory at the University of Denver. Recovering after 1893, Chamberlin secured a position with an American life insurance company in London. According to a London obituary, he died in 1897 of syncope and a weak heart while bicycling in Surrey. (Collection of the author.)

As their marketing trade tokens indicate, the Chamberlins had set out to create enclaves for prosperous residents outside other Western cities. Four of their targeted communities are named on one side: Denver, Pueblo, Fort Worth, and San Antonio. Andrew Carnegie's words on real estate wealth are on the reverse side. The developer did not live to see his lost Fort Worth suburb survive a depression, weather a journalist's sarcastic wordplay, or adapt to socioeconomic changes in the market for houses. (Courtesy of Dalton Hoffman.)

To take up the cause of selling and filling the suburbs, a group of investors issued a booklet (cover at left) featuring already-built homes in the early 1900s. Although the development still bore the Chamberlin prefix on official descriptions and transactions, the new vendors hastened to replace a surname associated with failure with a pleasant adjective, echoing language of the City Beautiful movement and real estate hyperbole of the day. Attorney Robert Lee McCart reclaimed the property Chamberlin's company had purchased; rancher and realtor Z. Boaz of Benbrook would purchase much of that land, and more to the west, prior to America's entry into World War I. (Courtesy of the History, Genealogy, and Archives Unit, Fort Worth Public Library.)

By 1917, promoters of Arlington Heights had deleted the "Beautiful" and (possibly) resorted to a generic line drawing of an ideal suburb with scarcely a vacant lot in sight in a *Fort Worth Star-Telegram* classified ad. (Courtesy GenealogyBank and NewsBank.)

From the second period of development, a plat map preserved by Robert Lee McCart and his heirs shows homes, a streetcar line, roads, a lake, parks, schools, a country club, a sanitarium, and the persistence of wide-open spaces. The boulevard cut diagonally through the addition's grid, but the trolley tracks veered off, then turned south toward Lake Como. As early as 1906, African Americans began settling to the south and west of the lake. (Courtesy of Alice Roberta McCart Walters and Roberta E. McAllister; photograph by Bob Lukeman.)

Francis Zelichowski (later officially simplified to Frank Zeloski) and his wife, Martha Kujawski Zeloski, brought their growing family to Arlington Heights from rooms at the Germania Hotel and Saloon, which he had managed in downtown Fort Worth. The Zeloskis' home, at the southeast corner of present-day Camp Bowie Boulevard and Zeloski Street, became the site of the Bowie Theater in 1941. (Courtesy of Frost Bank.)

Facing the camera and the boulevard, the Zeloski family poses in front of the house that was their home from 1907 until 1941. Cutting out a mixed-use suburban triangle—Zeloski Heights—Frank opened a service station and a commercial row on Camp Bowie Boulevard and delved deeply into real estate. After he died, Martha added a second commercial row. (Courtesy of Frost Bank.)

When local merchants collaborated to cheer the Fort Worth Panthers—predecessors to the Fort Worth Cats—to baseball victory over Alabama's Bears, local patriot and booster Frank Zeloski was the lone Camp Bowie Boulevard advertiser (second row from the bottom, fifth baseball from the left) in a full-page *Fort Worth Star-Telegram* display of commercial fandom on September 17, 1922. Others represented on the page had links to the boulevard and neighborhood: Steve Murrin and his downtown chili parlor, soon to relocate to a prime triangle on Camp Bowie Boulevard; Stonestreet and Davis, downtown clothiers instrumental in establishing the Arlington Heights Masonic Lodge No. 1184; and Jernigan Photo Service, which would capture many Camp Bowie people and scenes with regular and panoramic camera work during World War I. (Courtesy GenealogyBank and NewsBank.)

Cattleman and banker Earl E. Baldridge, his wife, Frances Gibson Baldridge, and their children lived for a few years in this stone mansion at the corner of Arlington Heights Boulevard and Sanguinet Street. The family then moved to larger and more imposing quarters on Crestline Road. In the 1930s, the Lena Pope Home for children relocated to this first of the former Baldridge mansions. (Courtesy of Earl Freeman.)

"JUST AS GOOD"

The Imitation Satin Man Advertises:

"MY 'NEAR SATIN' IS JUST AS GOOD AS THE REAL SATIN"

SUPPOSE THE BOARDING-HOUSE KEEPER SHOULD ADVERTISE: "MY NEAR-FOOD IS JUST AS GOOD AS REAL FOOD. WOULD YOU CONSIDER PAYING REAL MONEY FOR THIS KIND OF "GRUB!" ALMOST EVERY SUBURBAN REAL ESTATE DEALER IN FORT WORTH IS ADVERTISING HIS PROPERTY. WHILE SOME OF IT MAY BE CHEAPER IN PRICE, QUALITY IS NOT THERE.

Arlington Heights

IS AHEAD OF THEM ALL FOR BEAUTY AND GRANDEUR OF SCENERY. IN POINT OF LOCATION AND NEARNESS TO THE CITY THERE IS NOTHING TO EQUAL IT. THUS IT ACQUIRED THE NAME, "BEAUTIFUL ARLINGTON HEIGHTS." DON'T BE MISLED BY "NEAR-REAL" ARGUMENTS, WHEN YOU CAN BUY A HOME IN THE VERY HEART OF THIS BEAUTIFUL ADDITION. NO MATTER HOW MUCH OR HOW LITTLE MONEY YOU INVEST, REMEMBER THAT ARLINGTON HEIGHTS PROPERTY IS THE KIND OF PROPERTY YOU CAN RE-SELL FOR MONEY, THE KIND OF PROPERTY ON WHICH CONSERVATIVE BANKS AND TRUST COMPANIES WOULD LOAN MONEY ON. BUY WHERE THE ELITE OF FORT WORTH HAVE BOUGHT. DON'T WAIT—BUT AT PRESENT LOW PRICES AND REAP THE PROFITS, AS OTHERS ARE DOING.

Arlington Heights Realty Co. *Suburban Office:* Opp. Country Club, Arlington Heights. Phone 3077
DOWN TOWN OFFICE: Metropolitan Hotel, Facing N.nth Street. Phone 1972

Appealing to prospective buyers with high standards or, at least, a desire to turn a profit, successors to Chamberlin used a tactic designed to shame all bargain hunters and compromisers. The company placed this advertisement in the *Fort Worth Star-Telegram* on June 23, 1907. (Courtesy GenealogyBank and NewsBank.)

Two

The First Mile or So
A Bridge, a Park,
Marvelous Machines

Officer John Brown saw a man kiss a woman on a bench in Trinity Park Monday afternoon. "Here, now, you'll have to either drop that or get out of the park," warned Brown. "What is wrong about it?" protested the man. "This lady is my wife." "Well, this park is no place for a man to make a monkey out of his wife." The couple sat on the bench for a few minutes longer and then left the park. . . . If a couple insists on violating Officer Brown's warnings, he announces that the he will arrest them and send them to headquarters.

—*"You Can Wink, You Can Flirt, but You Can't Kiss and Hug: In Staid Trinity Park, of course—Chaperon Will Stay with Spooners, Too." Fort Worth Star-Telegram, May 19, 1914*

The legacy of the short-lived Chamberlin era included a bridge over the Trinity River's Clear Fork. It soon proved inadequate, but disputes over ownership of the bridge delayed the process of planning for other streetcar services in the early years of the 20th century.

City Park, later named Trinity Park, lay just across the river and beckoned to residents of the entire Fort Worth area. Playground rules were posted at the gates but sometimes flaunted, in modest preludes to late-20th-century flauntings.

Specialized recreational interests and investments brought a driving park to the area just west of the river in 1911. Bicyclists, motorcyclists, equestrians, automobile drivers, and flyers drew crowds to the park—especially a French pilot in his Bleriot.

In 1915, chamber of commerce and city leaders worked bargaining magic to persuade the Chevrolet Motor Car Company to build an assembly plant on Arlington Heights Boulevard adjacent to the Frisco railroad tracks. By 1916, it opened to fanfare and began a brief period of production and promotion.

As residents near the river reached a critical mass in two additions created by civic leader Maj. Klehber M. Van Zandt, a Van Zandt school district formed, and a frame school was constructed along the boulevard, halfway between the river and the beginning of Arlington Heights proper. After the first building burned down, a second one of brick and stone took its place in 1914, later to be absorbed into the Fort Worth public school system.

The new bridge, completed in 1913, was much more substantial than its predecessor and stayed in place for a century.

The late-19th-century bridge that allowed the original Chamberlin trolley to cross the Trinity River's Clear Fork became the subject of contention in the next phase of development, when heavier streetcars and increased road traffic required a sturdier structure. (Courtesy of Pete Charlton.)

Fort Worth's playground gained a formal entrance on July 4, 1908. In an account of the celebration, a *Fort Worth Star-Telegram* writer stated, "Bitterly crying, but too brave to give up, Little Monett Moffett, granddaughter of Mrs. J.P. Swayne, president of the City Federation of Women's Clubs, swung the bottle of artesian water that christened the new city park gate Saturday evening." (Courtesy of Dalton Hoffman.)

A photograph album compiled by Arthur Paddock and preserved by his daughter includes several scenes of excursions to Trinity Park, Forest Park, and other retreats. A South Sider, he would later move to Arlington Heights with his wife and children in the 1920s. Trinity Park events would range from labor union picnics featuring potato dogs and beer to "safe and sane" (temperance) celebrations, from late-1960s-early-1970s bohemian music concerts (and reunions) to lowrider gatherings in the 1980s, and from Shakespeare performances to the dedication of a law enforcement officers' memorial. (Both, courtesy of Dorothy Paddock Dixson.)

Roland Garros, a French aviator, performed daredevil tricks in his Bleriot craft on January 12 and 13, 1911. He took off from the Fort Worth Driving Park on Arlington Heights Road. Other feats included the launching of man-carrying kites. In Europe, Garros served his country as a fighting ace and befriended Jean Cocteau, taking the French philosopher on reconnaissance flights. Garros was captured and imprisoned by the Germans after a crash, escaped, and flew again for France and its allies, crashing and dying on October 5, 1918. (Courtesy of the *Fort Worth Star-Telegram* Collection, the University of Texas at Arlington.)

The new bridge connecting western suburbs to the center of Fort Worth opened on January 15, 1914. In March 1922, it was renamed the Van Zandt Viaduct. A *Fort Worth Star-Telegram* writer pointed out that, beyond its role in a system of cardinal roads, "Trinity Park, once avoided by many because of the old ramshackle bridge and dusty roadway, should become a great outing place for summer and the roadway onto Arlington Heights should soon be dotted with fine residences." (Courtesy of Quentin McGown.)

The Chevrolet Motor Car Company began turning out vehicles during the summer of 1917 from a massive two-story (later three-story) structure on Arlington Heights Boulevard, across from the present Montgomery Plaza, creating several hundred jobs. Although Chevrolet vacated the building by the mid-1920s, its impact continued for one future car dealer and political leader from Arlington, according to syndicated automotive columnist and broadcaster Ed Wallace: "Tom Vandergriff relayed the story to me of his father taking him to see that factory when he was a boy. It's what drove him to fight for the GM plant in Arlington as mayor," Wallace noted. (Courtesy of the Amon Carter Museum of American Art.)

Chevrolet displayed its 490 model and linked it with publicity for the Ellis Opera Company's local engagement in 1916. Factory tours were offered to opera patrons. (Courtesy of GenealogyBank and NewsBank.)

23

Although the city-created tourist camp appeared on a 1920 map, there was informal camping as early as 1918; it officially opened in 1923 with showers, writing and reading rooms, sanitary facilities, and guards. "Why can't all tourist camps be like this one?" A *Fort Worth Star-Telegram* interviewee asked. In keeping with a national trend, the park offered brief stays and some free services; some who stayed were refugees of drought. Others traveled for adventure. As private tourist courts began to proliferate, such services were discontinued. (Courtesy of Pete Charlton.)

Floodwaters rushed into low areas near the Clear and West Forks on April 25, 1922. Volunteers at the Van Zandt Addition School served coffee and crackers to the displaced. Persistence of the use of former street names is evident in the handwritten location, above; by the time of the flood, that section was named West Seventh Street. (Courtesy of the Tarrant County Archives.)

Three

CANTONMENT AND COMMEMORATION
ALL OVER THE MAP

Father Chataignon [Marius S. Chataignon, 1886–1957], the Catholic chaplain of the First Texas Infantry, . . . has seen service in the French army and has lost one brother in the present war. But his eyes are clear as he faces the future and his low musical laugh inspires much happiness. His is a bright, genial nature, which makes the boys of First Texas accept him as a comrade. . . . "When I am talking to them I never mention death," he declares. "Why should we?" he queries. "They are happy now, and why cloud their happiness? We know nothing of the future. Why not enjoy today?"

—Nell Flanagan
"Guardians of the Sorrows and Joys of the Soldier Boys."
Fort Worth Star-Telegram, October 7, 1917

Neighborhood developers foresaw a great economic advantage to hosting a military training camp in Arlington Heights for soldiers destined to ship out with the American Expeditionary Forces in World War I. But there was also a fear, expressed in local newspapers, that the soldiers' outpost would attract prostitutes, bars, and more. Thus, as in other communities where camps were established, various agencies and religious congregations sought to keep the soldiers down on the farm even before they saw "Paree." For the "Sammies" (as the French nicknamed US personnel, after Uncle Sam), there was also evidence of an outpouring of organized support, as well as the forbidden kind.

When Army engineers began to map out the base and construction crews went to work, it became clear that Camp Bowie had to be built around many of the suburb's existing private properties. Along parts of Arlington Heights Boulevard, civilians and soldiers were neighbors.

The 36th Division's soldiers and specialists boarded trains for East Coast bases and ports in 1918. In their wake, camp librarian William F. Seward noted, loyal companions gave voice to more than mere solitude and separation anxiety. "There came a day when several hundred dogs on the wind-blown, sand-blown, sun-baked reservation barked lonesomely and inquiringly at—nothing. Their masters had left for 'other points'—official language. One company telegraphed back to find, and ship to his home in a Texas town, their mascot, a great Dane. The post was a desolation of cleanliness, a desert of roofless shacks."

A monument, completed in 1937, stands at the crest of Blanc Mont Ridge, 38 miles west of the Meuse-Argonne American Cemetery. It honors soldiers of the 36th Division and others, French and American, who died before and during the Muese-Argonne Offensive in the Champagne region of France. Back home, Veterans' Park was established on a triangle of Texas earth in the area where the camp headquarters had stood. A sculpture, historical markers, and other elements commemorate the lives of those who once trained at Camp Bowie. Several groups, local and foreign, planted trees along the newly renamed Camp Bowie Boulevard, thinking of the Sammies who never came home.

C.H. Rogers's hand-drawn map made clear the location of many Camp Bowie facilities. In preparation for a Camp Bowie/World War I exhibition at the Fort Worth Museum of Science and History in 1996, a transparent overlay sheet was designed, allowing visitors to locate designated camp areas later covered over by new platting, extant but renamed streets, and other features. The inset at lower right shows related airfields. (Courtesy of Pete Charlton.)

Credited in this *Fort Worth Star-Telegram* montage for bringing the military camp to Arlington Heights are, from left to right, (top row) fresh produce distributor and chamber of commerce president Ben E. Keith, creditor H.C. Burke Jr., utilities executive J.C. Lord, city engineer F.J. Von Zuben, and newspaperman Louis J. Wortham, with bonds and securities man Ben O. Smith Sr. appearing below Von Zuben's photograph; (bottom row) candy, ice, and cold storage man John P. King, realtor L.O. Modlin, mayor W.D. Davis, and Northern Texas Traction Company division superintendent George H Clifford. (Courtesy of Genealogybank and NewsBank.)

Geologist Ellis W. Shuler, contracted to study the topography of the proposed camp location, indicated in 1917 that it was akin to the land on which the soldiers would confront the enemy in France. (Courtesy of the Dolph Briscoe Center for American History, the University of Texas at Austin.)

This aerial photograph of the camp captures the sweep of its coverage and the regimented layout of tents and other structures for its units. (Courtesy of David Pearson.)

Initially, the tents and some of the wooden buildings at Camp Bowie had dirt floors. Even a mess hall was without flooring. (Courtesy of Dalton Hoffman.)

Special railway routes were established to serve Camp Bowie. (Courtesy of Dalton Hoffman.)

The Buildings shown in this Book were Built by

BRYCE BUILDING COMPANY
Government Contractors

NURSES QUARTERS
BASE HOSPITAL MAIN MESS
CAMP LIBRARY
HOSTESS HOUSE
LIBERTY THEATRE
TWO RED CROSS BUILDINGS
BAKERY BUILDINGS

The Plumbing and Sewerage system for the entire camp, the sewerage disposal plant at Base Hospital, six miles of streets paved besides numerous other buildings and improvements were done by this Company.

REMEMBER THE
Star Produce & Commission Co.

¶ WHEN in need of Fruits and Vegetables for your Mess and Canteen

¶ WE maintain Special Service for the "Army Boys"---Try us

¶ Your Patronage highly appreciated

HARKRIDER-KEITH-COOKE CO.
FORT WORTH—WICHITA FALLS

FRUITS, PRODUCE,
GROCERS SUNDRIES
FOUNTAIN SUPPLIES

Circle (H) Quality

William Bryce, whose parents had brought him from Woolyburn Farm in Scotland to resettle in Ontario, Canada, had learned his family's business of making and selling building materials. He left on his own for the United States, prospered in Fort Worth, and inhabited one of Arlington Heights' earliest, architect-designed, elegant homes. He won a large share of contracts for Camp Bowie's construction. Bryce, among the earliest Arlington Heights residents, was a civic leader who later served as mayor of Fort Worth. He and 50 residents of Irish, Scottish, Welsh, English, and British colonial birth formed the British-American Society in Fort Worth in 1915, before the United States became militarily involved in the war. The group raised funds to assist orphans of the war in Europe. (Courtesy of Dalton Hoffman.)

Choctaw Indians Visit Relative at Camp Bowie

Many relatives and friends of soldiers at Camp Bowie visit them daily. Among the visitors Wednesday were three Choctaw Indians from Oklahoma. In the photograph are shown T. C. Solomon of Company E, Hundred and Forty-second Infantry, and his brother, mother and uncle, left to right: D. C. Solomon, Mrs. Christen Solomon of Cloudy, Okla.; T. C. Solomon and Rob-ert Parish of Darwin, Okla. —Photograph by Jernigan.

Family visitation may have resulted in the recruitment and addition of another son to the American Expeditionary Forces. T.C. Solomon survived the war, but his brother, D.C. Solomon, was killed in France. (Courtesy of GenealogyBank and NewsBank.)

In preparation for chemical warfare overseas, Camp Bowie men drilled with gas masks. As Ben-Hur Chastaine recalled in *The Story of the 36th*, French and British specialists came to the camp to set up training schools focusing on combat and survival skills they knew the Americans would need to master. "So efficient was the gas school," Chastaine wrote, "that every officer and enlisted man passed through the divisional gas chamber sometime during the winter and spring and learned how to manipulate the new gas mask that had been fashioned for American troops." (Courtesy of Ben Guttery.)

While some Native American units stayed together, others were dispersed among non-Indians. Ben-Hur Chastaine included two photographs of Indian servicemen in his book *The Story of the 36th* and praised their service. In the practice trenches, closer to Stove Foundry Road (present-day Vickery Boulevard) than to Arlington Heights Boulevard, every soldier spent time in the subterranean network, earning the nickname "new cave men" invoked in a local newspaper feature. Tragically, trainees were killed in one simulated trench attack. (Courtesy of the History, Genealogy, and Archives Unit, Fort Worth Public Library.)

Although of lesser quality than other images of bayonet practice, the one derived from Oklahoma City journalist Ben-Hur Chastaine's book conveys a mechanized eeriness. Chastaine had gained earlier military experience as a Tennessee National Guardsman by pursuing and arresting Ku Klux Klan members in Northwestern Tennessee in 1908. Through the *Fort Worth Star-Telegram*'s "Fall In" column of September 13, 1917, local readers learned of his role in quelling a "campaign of desperate deeds, which included the twice burning of the big fishing docks on Reelfoot Lake, the whipping of women and children and old men, the terrorizing of social activities and which finally culminated in the killing of Capt. Quentin Rankin of Walnut Log hunting lodge." He had also served with John Pershing at the Mexican border during the pursuit of Pancho Villa. (Courtesy of the History, Genealogy, and Archives Unit, Fort Worth Public Library.)

Snow scene of 111th Engineers Camp Bowie Texas Monday Jan'y 21st 1918 By Liberty Studio Camp Bowie

Soldiers felt the first winter at Camp Bowie to their bones. Shortages in winter uniforms, blankets, comforters, and other basics led to extreme discomfort and illness. After they returned from a Christmas furlough, a four-inch snowfall in 1917 delayed training. In Gregory W. Ball's book *They Called Them Soldier Boys*, one man remembered engaging in "bloodless battles, in which snowballs instead of cannonballs, were used as ammunition." (Courtesy of Dalton Hoffman.)

Despite its cheerful narrative, *The Capsule*, a publication of the base hospital, included a share of irreverence and hard truth. (Courtesy of Ben Guttery.)

J. Frank Norris, on at least one occasion, recruited his entire First Baptist Church congregation to Camp Bowie for a service and replaced a large tent with a wooden building as the tabernacle for soldiers. Focused on keeping them occupied, he advertised one wartime sermon in the newspaper: "Millions for entertainment and pennies for salvation." The Jewish Welfare Board, Knights of Pythias, and Salvation Army all established "huts" on the base, and the Methodists also built a tabernacle. (Courtesy of the *Fort Worth Star-Telegram* Collection, the University of Texas at Arlington.)

WAR DEPARTMENT
OFFICE OF THE CAMP QUARTERMASTER
CAMP BOWIE, TEXAS

No.

From :

To :

Subject:

Out in the sticks of Texas,
Far from the haunts of men,
There's a hole in the ground called Bowie,
Where they live like pigs in a pen,
Where the silence echoes from the hill-tops,
Land-locked in a sea of mud,
Where the sun comes up and the sun goes down,
And the cactus bloom and bud,
Where the tree-toad yoddles his chorus,
And the horse-flies buzz and bite,
And the weary days slide by side-ways,
And the hound dogs bark in the night,
It's an ideal spot for a grave-yard,
Dreary, gloomy, and damp,
But can any one tell why in the name of Hell,
They chose this place for a camp?

Choral singing was organized for soldiers as part of their recreation, but poets—some of them anonymous—waxed eloquent about aspects of life in the tents. (Courtesy of Dalton Hoffman.)

The engineer in charge of construction at Camp Bowie wrote, in retrospect, that he disapproved of the plan for building the camp around existing homes and other properties. He recommended a neatly gridded territory with no distractions from stores, for example. It made for such scenes as the 111th Engineers standing at attention near a source for hot and cold lunches. (Courtesy of Dalton Hoffman.)

"There is no more democratic place on the reservation than the camp library," asserted William F. Seward, the man in charge, "and with a lawn, window flower-boxes, palms, ferns, pictures, letter-writing materials, and no signs, no 'don'ts', we tried to make it an attractive and friendly place." The American Library Association's repository, shown here, faced north on Arlington Heights Boulevard. According to Seward, the main collection consisted of about 12,000 volumes; a second, much larger collection "was fluid, changing from day to day" as books arrived from libraries in five states, to be "stored, temporarily, in bedroom, storeroom, platform, tent, in boxes of varying capacities." Fifteen to 20 sacks of donated magazines arrived weekly. Beyond supplying reading material and a place to read, Seward discovered, soldiers needed the librarian to be a good listener. (Courtesy of Dalton Hoffman.)

Liberty Theatres, on the "Smileage Circuit," featured Army-approved films, fighting matches, and other entertainments. Yet soldiers ranged beyond the camp's boundaries, and theater owners wrestled politically with sabbatarians who wanted to prevent Sunday entertainments. Pierre Levy, manager of the Hippodrome and Strand Theaters and president of the Fort Worth Motion Picture Show Managers' Association, spoke his mind to a newspaper reporter on the day he announced that Fort Worth's screens and stages would reactivate on Sundays: "We have heard the call of our fighting men and we are offering them the best we have. . . . We will continue to open our theaters on Sundays because there is not only a demand but a necessity." Although he had been fined for Sunday screenings and ordered by local authorities to close his theaters on the Christian sabbath, Levy argued, "The government has depended largely on the picture shows to float the Second Liberty Loan, to conserve the food of the nation, and to state the nation's war aims . . . and now the nation is depending upon us to give her boys a day of amusement." The Army and Navy had also sent representatives to Fort Worth to persuade local authorities to lighten up. (Courtesy of Dalton Hoffman.)

Through service at the YWCA Hostess House, matronly and young women pledged to provide homelike hospitality and morally upright socializing. (Courtesy of the National Archives.)

35

The Red Cross presence was strong at Camp Bowie. Chevrolet donated one of the 490 sedans (named for the dollar price) that employees had assembled at the Arlington Heights Road plant to the Red Cross for camp service work at Camp Bowie. Volunteer Anna Lee Ballard served as the chauffeur. (Courtesy of Ben Guttery.)

In *The Capsule*, a publication of the base hospital staff, the work of the x-ray room and its bedside unit was described in detail. "The number of plates the department has made runs in the thousands," the editor noted. "The majority . . . consists of pneumonia, empyemas, fractures and foreign bodies, such as machine gun bullets, fragments of shells, etc." Dental officers also had access to the facility. (Courtesy of Ben Guttery.)

Camp Bowie's nurses, shown here in a photograph from *The Capsule*, together with other medical personnel, treated soldiers stricken with influenza and other contagious diseases. They also cared for returnees who had been wounded in France. (Courtesy of Ben Guttery.)

Nurses were housed in dormitories on the hospital complex on the camp's west side. Although plans were announced to offer the nurses boxing lessons for self-defense, protest and pressure quickly resulted in cancellation. (Courtesy of Dalton Hoffman.)

Headquartered along the south edge of Arlington Heights Boulevard, east of Reika (present-day Montgomery Street), the 111th Ammunition Train encamped and prepared for its essential and

"It is incredible there could be so many mules in the world as I saw at Camp Bowie," marveled librarian William F. Seward. "That here could be so much hay in the world and enough mules to eat it and then bray for more. . . . Within twelve hours of my arrival I gave the right hand of fellowship to a dozen ministers and the right of way to 500 mules." Even before US involvement in the European war, George Pattullo noted in his January 30, 1915, *Saturday Evening Post* article, "They are feeding mules to war's maw, and the foreign buying of American hybrids is large." When asked about the controversial notion of such sales, a member of the Rominger family of horse and mule dealers in North Fort Worth's stockyards area gave Pattullo an earful. " 'Listen!' said Rominger, 'Listen good! You hear people making a roar about shipping these horses abroad. Why shouldn't we? This trade will help out the cotton farmer just when he needs it. You know as well as I that a lot of them have been on the verge of starvation.' " (Courtesy of Ben Guttery.)

38

risky overseas assignment: delivering artillery and infantry ammunition from the refill station into the fray. Private houses, billboards, and more stood nearby. (Courtesy of Dalton Hoffman.)

Not swords into ploughshares, but rather ammunition shells cleaned out and put to use as salt and pepper shakers for a well-appointed postwar table, these artifacts were among items salvaged by civilians after the mustering out of thousands of soldiers at Camp Bowie and the hasty dismantling of the temporary facility. (Courtesy of Michael McDermott.)

Pearl Trammell, a poet, clubwoman, and the wife of the city engineer J. Davis Trammell, campaigned in 1919 for a commemorative or victory arch to be built at the western terminus of the Seventh Street Bridge or at the beginning of the newly named Camp Bowie Boulevard. Evidently, the arch was never built. (Courtesy of the Amon Carter Museum of American Art.)

Fort Worth native Barvo Walker, who grew up in Arlington Heights, sculpted *Duty* for Veterans' Park on the site of the camp's command headquarters; he completed the first sketch in 1982 for a small group of World War I veterans who sold their building to pay his commission. The work was unveiled on November 11, 1987, in the triangular park at Camp Bowie, Crestline, and Thomas Place. (Courtesy of Barvo Walker.)

Arthur Loomis Harmon, architect of the Empire State Building, designed the Sommepy American Monument atop Blanc-Mont Ridge for the American Expeditionary Force's 36th Division and others. Vestiges of trenches, dugouts, and gun emplacements surround the limestone tower northwest of Sommepy-Tahure (Marne), France, in the Champagne region. (Collection of the author.)

Four

Bungalow Boomers
Post–World War I Arlington Heights

It's a fast life out in Arlington Heights now. All near suburbanites who live on the Heights are agreed to this. The speedy living hit them this week. The slow cars that have long made the run have been taken off, and the little green "safety cars" now breeze along."

—"Life Grows Fast on Arlington Heights"
Fort Worth Star-Telegram, November 26, 1919

Whereas the first and second developers had envisioned stately homes on large lots, the third push for populating Arlington Heights appealed to a range of middle- and upper-middle-class buyers. Smaller bungalows and English-cottage-style homes materialized on smaller lots over the former military campgrounds.

The first landmark—the Masonic lodge—appeared on the boulevard in 1922, followed by modest starter churches, one-story commercial rows, and other structures. Some of these appeared on streets that angled off of Camp Bowie Boulevard and offered valuable boulevard frontage. By the beginning of World War II, many of the Arlington Heights lots facing Camp Bowie Boulevard were occupied, although streetcars gave way to city buses in the mid-1930s and the center track spaces were converted to green parkways.

Fort Worth Star-Telegram columnist Bud Kennedy paid tribute to a favorite diner, Rockyfeller Hamburger System No. 22, a survivor from the 1930s. In his July 12, 1991, *City Beat* essay, he told of its sale and imminent departure. Although another unit stood on the city's North Side, Kennedy made a final visit to 4015 Camp Bowie Boulevard. He surveyed the interior, noting that the booths and jukebox were missing, but "the chrome kitchen and the 1960s Vandervoort's milk cooler remained," and wrote, "This was *my* Rocky's." When Kennedy and his wife, Shelly, were searching for a home, they looked for a place within quick driving distance of their shared favorite frozen custard source of the 21st century. Curly's, at the corner once occupied by Frank Zeloski's gas station and a few steps from the old Rockyfeller site—both in the triangular Zeloski Heights addition—held a special attraction. "We wanted to live in Curly Heights," Kennedy told an audience of Arlington Heights Neighborhood Association members in 2012.

Within four years, the neighborhood–turned–military camp–turned–neighborhood had begun to look like a place to call home. Improved streetcar service, new commercial rows, and rapid residential development came together with great momentum. City leaders noticed this, and annexation occurred in 1922. Arlington Heights Lodge No. 1185, Ancient Free and Accepted Masons, claimed instant landmark status. Paving bricks produced in Thurber, Texas, covered the boulevard in 1928, forever endearing it to some and causing others to curse it. Most drivers, passengers, pedestrians, bicyclists, and motorcyclists have their Camp Bowie Boulevard stories.

The Northern Texas Traction Company created a new level for its tracks along the boulevard. (Courtesy of the *Fort Worth Star-Telegram* Collection, the University of Texas at Arlington.)

Actress Martha Hyer recalled: "Coming home from a dance . . . in my senior year [at W.C. Stripling Senior High School]. . . . It was raining, and the car skidded into a telephone pole—no drinking, no drugs, just an oil-slicked Camp Bowie Boulevard. My date and I were in the backseat. I leaned forward to warn the driver, but the brakes locked in the skid. As we hit the pole, I smashed into the back side of the front seat, bending it into an inverted V." (Courtesy of the Local History and Archives Unit, Fort Worth Public Library.)

Muralist Stylle Read brought color and life to his interpretation of the 1920s boulevard experience in the heart of Arlington Heights. He adorned the exterior walls of Historic Camp Bowie Mercantile at the Weatherford traffic circle, where Camp Bowie Boulevard ends and the newly named Camp Bowie West Boulevard begins. Holt Hickman commissioned Read's series of murals to show residents the layers of history along the way. (Photograph by Karl Thibodeaux.)

43

Within three years of Camp Bowie's closing, bungalows and cottages, commercial rows, a fraternal lodge, churches, and a fire station had begun to replace the military layout in Arlington Heights. (Courtesy of David Pearson.)

This photograph, taken four years after the previous aerial image, shows how the proliferation of new residences made the transformation nearly complete. Only a few vacant lots were left on most blocks of Arlington Heights by the time World War II began, halting new construction. (Courtesy of David Pearson.)

The congregation of Arlington Heights Methodist Church gathered before the World War I Camp Bowie hospital building they called "the Shack" in 1920. By 1928, the members had raised enough funds to commission architect Wyatt C. Hedrick to design a Tudor Revival educational building with a basement and a temporary sanctuary on the second floor. The larger sanctuary was completed in 1952. (Courtesy of the *Fort Worth Star-Telegram* Collection, the University of Texas at Arlington.)

A Methodist leader's compliment to the neighborhood congregation, included on a map for visitors, would be echoed in later eras, when realtors and real estate enthusiasts would repeat a phrase attributed to the legendary New York developer William Zeckendorf: "Location, location, location." (Courtesy of Arlington Heights United Methodist Church.)

TO THE PEOPLE OF ARLINGTON HEIGHTS

This Bulletin is presented to you with the compliments of the Arlington Heights Methodist Church. Please read it.

YOU ARE INVITED

to attend the services of our church at any and all times. We extend to you a cordial welcome to place your membership with us. The opportunities of service in the community are plentiful. We are glad to share them with you.

"Grow old along with me,
The best is yet to be."

The future of the Arlington Heights Methodist Church was assured when you purchased this site.

— F. P. Culver

45

Arlington Heights, annexed by the City of Fort Worth in 1922, benefited from the addition of bungalow fire stations in several neighborhoods. Station No. 18 (shown here), which celebrated its 90th anniversary in June 1913 with a neighborhood party, continues to serve, although its interior has been gutted and altered dramatically. (Both, courtesy of the History, Genealogy, and Archives Unit, Fort Worth Public Library and the family of the late Jim Noah of the Fort Worth Fire Department and Station No. 18.)

46

The first of the Texas Pacific Coal and Oil Company's octagonal TP Aero stations opened in 1928, marking the eastern entrance to Camp Bowie Boulevard at its intersection with West Seventh Street, Bailey Avenue, and present-day University Drive. The station changed hands and companies, suffering demolition and replacement in the 1970s. In his history of the company, Don Woodard noted that it was the "largest and most prom. TP station in FW." The land has been the property of the Barney Holland Oil Company, also founded in 1928, for many years. (Courtesy of Pete Charlton.)

Brother Masons set the cornerstone for their lodge on May 23, 1922. (Courtesy of Arlington Heights Masonic Lodge No. 1184, A.F.&A.M.)

47

Horace A. Litsey bought the Dave Reaves Sanitary Well Water Company on West Fifth Street, a few blocks north of the boulevard, in 1923. His horse-drawn and sometimes mule-drawn wagons carried artesian water in wooden barrels along Camp Bowie Boulevard. The company also pumped artesian water to nearby homes and businesses. (Courtesy of Julie Litsey Voigt, Bubba Voigt, and the Monticello Spring Water Company.)

The Cameo occupied a space within the Zeloski commercial rows. (Collection of the author.)

48

Built in 1909 and facing the boulevard, the Arlington Heights School served students long after Fort Worth had absorbed the neighborhood district. Its generous and gently sloping eaves were lopped off sometime after this 1946 photograph was taken. (Courtesy of the Billy W. Sills Center for Archives, Fort Worth Independent School District.)

When public works crews began to improve the landscaping of school campuses in the 1930s, the Arlington Heights School still had its spiral fire escape slides. In 1954, a linking structure connected the 1909 schoolhouse and the 1922 high school to expand Arlington Heights Elementary School. During that era, the gifted Scott and Stuart Gentling were enrolled there. Progressive teachers worked with them in a way that Stuart would recall, years later, in the preface to the brothers' *Of Birds and Texas*, a limited-edition boxed portfolio of prints from 40 of their bird paintings and 10 landscapes. "The first wild predatory birds that Scott and I raised were two diminutive but fearless Loggerhead Shrikes. They were brought to us late one spring by a schoolmate as little more than very young nestlings just beginning to fledge. Our sixth-grade teachers at Arlington Heights Elementary School were very understanding and permitted us to bring the birds to school, letting us feed them at appropriate times." The twin painters, who learned to love the work of John James Audubon while visiting the Children's Museum (the present Fort Worth Museum of Science and History), also incorporated birds in flight into one of their interior domed-ceiling murals commissioned for Fort Worth's Nancy Lee and Perry R. Bass Performance Hall. (Courtesy of David Pearson.)

Designed by the architectural firm of Clarkson and Gaines and built by Harry B. Friedman, the first Arlington Heights High School was completed in 1922. It stood alongside El Campo Avenue, facing Camp Bowie Boulevard, west of the 1909 Arlington Heights School. (Courtesy of the Billy W. Sills Center for Archives, Fort Worth Independent School District.)

Gathered facing the boulevard, Arlington Heights High School's seniors of 1925 pose for their on-campus class photograph. (Courtesy of the Billy W. Sills Center for Archives, Fort Worth Independent School District.)

Frank Zeloski invested in the creation of a commercial row on the south side of Camp Bowie Bouelvard in 1924; it encompassed storefronts with the addresses 3901 to 3923. An addition on the west was built in 1930. From bakeries to beauty parlors, a butcher shop, and a bowling supply store, the Zeloski rows held many businesses and stories. (Courtesy of Michael McDermott.)

Within a decade of graduation, western swing pioneer Milton Brown would found the band Milton Brown and his Musical Browies. He appeared on the football team in the 1925 *Yellow Jacket* yearbook with fellow end Harold Powell and guard Bob Schmitt. In one of his many high school roles, he led the pep squad with Augusta Pearl Barton (above). (Courtesy of the Billy W. Sills Center for Archives, Fort Worth Idependent School District.)

Ben Eastman's Hill Crest Service opened in style at a prime location—the corner of Camp Bowie Boulevard and Clover Lane—in 1922. Eastman, with an enthusiasm for marketing and a gift for keeping loyal customers, built up a clientele so large that he eventually had 22 or more employees on hand. (Courtesy of Ben Eastman Jr. and Gordon Eastman.)

Planned before World War I, the Hill Crest Addition came into its own after the military camp closed down. A copy of the official map hung in the office of Ben Eastman's station for many years. (Courtesy of Ben Eastman Jr.)

Mary Eastman, standing with her back to the wheel, delighted in the giant Goodyear tire that rolled into her father's station as a promotional stunt. A motorbus pulled the 12-foot-tall tire across the country in 1930 to promote the company's all-weather-tread supertwist cord tires. (Courtesy of Ben Eastman Jr.)

Ben Eastman (at right) welcomes Goodyear Aviation representatives and their pilot during a promotional campaign. The company had introduced the first airplane tires in 1909. (Courtesy of Ben Eastman Jr.)

After Ben and Edna Staats Eastman moved from Arlington Heights to a rural retreat in Benbrook, Hill Crest Service's owner began a tradition of inviting a multitude of friends and regular customers to an annual barbecue in the pecan grove he had planted there. By the time a caricaturist reinvented him as a sheik (shown here), Eastman had been portrayed as a pirate in a tire advertisement, a cowboy with a five o'clock shadow in the Amon Carter–commissioned booklet *Poker*, and as himself—a derby-wearing, suit-clad hail-fellow-well-met on his own logo and sign. (Courtesy of Ben Eastman Jr.)

Ben Eastman's Benbrook neighbor, Z. Boaz, who also had a gasoline station/garage and a ranch in the Benbrook area, found his place marked on the Eastman barbecue party map. (Courtesy of Ben Eastman Jr.)

54

"The grease man" at Hill Crest Service, L.C. Wiggins, worked there for many years. He was, Ben Eastman Jr. recalled, a respected community leader in the nearby Lake Como neighborhood. (Courtesy of Ben Eastman Jr.)

An attendant lifts a massive hood. Dave Pearson, who joined the station staff as a teenager, learned to play guitar from Matthews on occasional breaks. With its prime corner location and large garage, the station boomed. (Courtesy of Ben Eastman Jr.)

Gerónimo Pineda (standing in the back, at right) presided over the dining room of the Original Mexican Eats Café, which he and his wife, Lola San Miguel Pineda, founded. Lola inspected every dish before it left the kitchen. (Courtesy of Patricia Kane Ray.)

The Pinedas' daughter, Ruth (front), joined her friend, Virginia Little, outside the café. Although her heart had been damaged by rheumatic fever, Ruth helped at the Original. (Courtesy of Thomas Kane.)

Gerónimo Pineda (right), a native of Barcelona, served in the Spanish military through the end of the Spanish-American War and then decided to stay in the Americas. He sold insurance at first, and then he and his wife started their first restaurant in Waco. Lola San Miguel (right) was born in Laredo; her parents had come to the United States from Múzquiz, in Northern Mexico. Together, they founded the Original. According to the research of Carlos Cuellar for his history dissertation and book, *Stories from the Barrio*, the Pinedas set a precedent by opening a Mexican restaurant outside a traditionally Mexican neighborhood. (Both, courtesy of Thomas Kane.)

Lola (left) and Ruth play and pose in the rare Texas snow outside their first Arlington Heights home on Kenley Street, a few steps from the restaurant. Later, the family lived on Ashland Avenue, and when Ruth's sister Eva married John Kane, they bought the house next door. (Courtesy of Thomas Kane.)

An event that is difficult to document but highly likely, according to Pineda grandson Thomas Kane, is a fabled meal shared by Franklin Delano Roosevelt, his son Elliott Roosevelt, and Amon Carter during one of the president's visits to Elliott and his family. Elliot's favorite platter still bears the family's surname: the Roosevelt Special. Fort Worth artist Lane Ann Kimzey captured the legendary visit in a montage that hangs in the foyer of the restaurant. Truett Kimzey, her father-in-law, was engineer for radio station KFJZ (owned by Elliott Roosevelt), and she incorporated his photograph of a live presidential radio broadcast into the painting. (Photograph by the author.)

Portions of the film *Strategic Air Command* were shot in Fort Worth, bringing the actor James Stewart to town in 1955. On a return visit two years later, Stewart and his wife, Gloria Hatrick Stewart, shared a meal at the Original's southwest corner table—the one normally reserved for the Pinedas and the Kanes. (Courtesy of Thomas Kane.)

Joseph Crumbie opened Crumbie's Coffee Shop midway through the Great Depression in the first of the Zeloski commercial rows on Camp Bowie Boulevard in Arlington Heights. Although the shop did not go broke, their son reminisced, it did not make enough of a profit. "My father wanted to run a Cadillac coffee shop," Robert Crumbie noted. Crumbie went on to serve as executive secretary of the Texas Restaurant Operators, Inc. (Courtesy of the Texas Department of Transportation.)

When Frank Burkett approached the owner of Snyder's Meats on Camp Bowie Boulevard regarding the purchase of an advertisement in the handmade neighborhood newspaper the *Shooting Star*, he was told that the deal must include a picture of the young woman who kept the market's account. Frank sketched her, and the advertisement ran in one of the World War II–era issues. (Courtesy of Frank Burkett.)

Country Club Christian Church began in a series of home meetings, and on March 16, 1924, 40 people signed on as charter members. Soon afterwards, they renamed it Arlington Heights Christian Church. They met at the Masonic lodge for several months, bought a lot at the corner of Camp Bowie Boulevard, Kenley Street, and Bryce Avenue, and moved into a building constructed by members—or, as one keeper of church history believes, it may have been a military base structure or a building made of salvaged Camp Bowie materials. The membership represented the Disciples of Christ (Christian Church) denomination in the suburb. (Courtesy of Arlington Heights Christian Church.)

In 1964, the congregation determined to replace its 1940 sanctuary; architect Herman G. Cox designed the new one, but the membership kept the 1951 educational and fellowship building. From the new construction site, one could survey the Green Front Store within the 1926 Martin Commercial Building, the Toy Chest within the 1927 Helpy-Selfy Store building, and the Sinclair station designed by Arlington Heights resident and architect Manvel Ervin. (Courtesy of Arlington Heights Christian Church.)

Members of present-day Connell Baptist Church built their facility on Bryce Drive in several modest stages, beginning with a roofed basement in the 1920s. Originally named Arlington Heights Baptist Church, it became a memorial to a prominent member. (Courtesy of Connell Baptist Church.)

Although the Trinity Park Baptist congregation planned, after World War I, to build a much larger church at the corner of Camp Bowie Boulevard and Dorothy Lane to be named Soldiers' Memorial Baptist Church, those plans did not materialize. By the late 1930s, however, Arlington Heights Baptist Church had added an educational wing to its barn-like auditorium. (Courtesy of Roy Lee and Ellen Brown.)

Assembled for their annual group picture, the residents of Lena Pope Home sat on the stairway of the former Baldridge mansion at 4108 Camp Bowie Boulevard. A women's Sunday school class at Broadway Baptist Church on the near South Side founded the children's residence and relocated it in 1933. (Courtesy of the Lena Pope Home.)

A housemother dines with six of the boys who lived at Lena Pope Home. Their dorms, faced with native sandstone, were built by day laborers recruited by Lena Pope. In some cases, child residents assisted in the construction. (Courtesy of the *Fort Worth Star-Telegram* Collection, Special Collections, the University of Texas at Arlington.)

On a warm day in 1956, Helen Doris Freeman holds her son Earl Ray Freeman's hand as they walk across the Lena Pope Home campus at Camp Bowie Boulevard and Sanguinet Street. Earl's older brother Floyd Lee Freeman follows, and a friend, Glenda Hope, accompanies them. Helen had decided, with the help of a pastor and Lena Pope, to take her four children and herself out of an abusive marriage and family situation. Her way out was to hire on as a boys' dormitory houseparent at the children's home and to enroll her children as residents, although it was a mixed blessing. "I woke up every morning to the smell of urine," Earl recalled. "The fact that our mother made that one decision on a hope and a prayer is part of the reason we're all where we are today." (Photograph derived from home movie, courtesy of Earl Ray Freeman.)

Floyd Leach Johnson, maternal grandfather to the Freeman children—Floyd Lee, Earl Ray, Linda Gay, and Robert Dee—was an independent lawn and landscape man who worked for more than 50 years in Arlington Heights with a modified Cushman cart as his only vehicle. He took his grandchildren in at various times of transition and participated in their lives while they were at the Lena Pope Home. On the Sanguinet sidewalk bordering the home, he allowed Earl to drive the Cushman while Floyd Lee pushes and Glenda Hope hangs on. (Photographs derived from home movie, courtesy of Earl Ray Freeman.)

63

Steve Murrin's triangular cream-brick, tile-roofed structure attracted many regular diners beginning in the late 1920s. The 1946 Arlington Heights High School student directory and handbook carried a full-page advertisement for the business. (Collection of the author.)

Followers in the footsteps of Steve Murrin's establishment included, briefly, a project of the owners of Renfro's Drug Stores. The dining room was rented out for special occasions. (Courtesy of the Amon Carter Museum of American Art.)

The Presbyterians of Arlington Heights were among the first to establish a religious congregation in the neighborhood, in 1922, but their sanctuary was built after World War II. Authors of the congregation's 32nd anniversary book noted, "The first building at the time the church was organized was a one-room structure . . . known as the Klan Building." They quickly converted it to another purpose. (Courtesy of Elizabeth Wood.)

Charter member Mrs. F.J. McMillen (Ida) shovels a measure of ground-breaking dirt for Arlington Heights Presbyterian Church's sanctuary in 1948; the Reverend James Aiken, left, stands by. The congregation disbanded in 1965; the nondenominational Partners in Prayer kept the building open for years, then it served as a Christian Science reading room and worship space until the mother church sold it. (Courtesy of Elizabeth H. Wood.)

Meadlin's service station, seen here in 1941, stood at the intersection of Merrick Street, Pershing Avenue, and Camp Bowie Boulevard. The car parked on the right, near the water tower and across the boulevard, belonged to Molly, a carhop at the booming Joe Vigne's, a barbecue drive-in restaurant east of the station. Horace Meadlin managed the station at the corner of Camp Bowie and Merrick for decades, employing his sons Larry and Wayne when they reached their teens. (Courtesy of Wayne Meadlin.)

Angling off of Camp Bowie Boulevard, many cross streets offered frontage that was equally visible within the first block or so. Charles Kincaid, pictured here with his truck, went to city hall to get his grocery store's address changed from Collinwood to Camp Bowie Boulevard. Kincaid's began as Pope-Kincaid, a Clover Farms Store, in the late 1940s, but Roy Pope, the senior partner, opted to focus on full-time management of his other store, Roy Pope Grocery on Merrick Street. After years of providing home delivery and catering services, Kincaid's evolved into a hamburger mecca that was immortalized in a book by Glenn Dromgoole in the 1980s. Eventually, the owners dispensed with the grocery business and focused on the burgers. Offering deep discounts for burgers on the store's 60th anniversary, they discovered a waiting line of Kincaid's burger fans around the block for the entire day. (Courtesy of the Gentry family.)

George Norris, son of J. Frank Norris, opened his own church on Camp Bowie Boulevard in the 1950s. They formed Gideon Baptist Church, building in stages at 4449 Camp Bowie. Gideon Baptist Church was independent from the Southern Baptist Convention. After the congregation disbanded, a Bible church—Christ Chapel—occupied the building for several years, and then the Texas Girls' Choir made it their home. In his book *God's Rascal: J. Frank Norris and the Beginnings of Southern Fundamentalism*, Barry Hankins documented the split that occurred in 1944–1945 between father and son clergymen at Fort Worth's First Baptist Church and the exodus of the son, George Norris, and other members. (Collection of the author.)

The "Cradle Roll" class of Gideon Baptist Church soaks up the sun on the side lawn on a Sunday in the early 1950s. Whenever Bettie Moore Griffey had gotten all five of her young children dressed up to get to Sunday school on time, she told a friend, she felt that she had really accomplished something. Karen Griffey, the family's only daughter, stands at the far right. (Courtesy of Karen Griffey and the Griffey family.)

The Bowie Theater's moderne neon tubing glowed above the corner of Camp Bowie and Zeloski Street, and it was nighttime when Interstate Theaters' founder and president, Karl Hoblitzelle, took part in the grand opening on January 31, 1941. The chamber of commerce magazine's feature on the new cinema house noted such highlights as Acousticon ear plugs for the hard of hearing and several wide seats "enabling larger persons to sit in unusual comfort." These would later be claimed for romantic couples' moviegoing. (Tri-Foto photograph by Robert Gordon Jones, courtesy of Logan Baker.)

The lobby design allowed for strategically placed images of upcoming features. In his novel *Lords of the Earth*, set on Fort Worth's west side, Patrick Anderson included an encounter between an estranged paternal grandfather and his young grandson at the downtown library on a Saturday morning during World War II: "I understand you go from here to a matinee movie at the Bowie Theater." "That's right. I get an allowance. Eleven cents for the movie and a nickel for a candy bar, and ten cents for a stamp for my savings-bond book and ten cents to ride the bus to the library and back. That's 30 cents a week." (Photograph by Don Loyd, courtesy of Logan Baker.)

Cub Scouts fill the front center seats of the Bowie for a Saturday screening of Walt Disney's *101 Dalmatians* in March 1961. (Courtesy of *Fort Worth Star-Telegram* Collection, the University of Texas at Arlington.)

During the same showing of the Disney cartoon, Cruella De Vil may have loomed on the screen at the moment a photographer captured the profiles of Earl Wayne Stamp (left) and Bonnie Collins (right), but their companion, Don J. Crosby (center), is drawn to the click and flash of the camera. (Courtesy of *Fort Worth Star-Telegram* Collection, the University of Texas at Arlington.)

The Chicago Corporation, a holding company led by Earl Baldridge, bought the Champlin Oil Company as the result of a strategic negotiation that Baldridge described in detail to his employee, Grace Halsell; she would later retell it in a memoir. The selection of Karl Kamrath as architect for the Chicago/Champlin office building at 5301 Camp Bowie Boulevard was a bold choice, introducing Frank Lloyd Wright's influence to the boulevard in 1954. Kamrath, a tennis star before he entered the architecture field, and H.H. Champlin, founder of the independent oil company, both came from Enid, Oklahoma. (Photograph by W.D. Smith, courtesy of the Alexander Architectural Archive, the University of Texas at Austin.)

The Taj Mahal Apartments' exotic northern facade beckoned to prospective tenants with a golden spire rising above an ironwork gate and a layer of California lava rock at 5225 Camp Bowie Boulevard. The complex opened in 1963, with choices of Chinese modern or Italian furniture. Other features of the luxury complex included wood-burning fireplaces. Later in the decade, Hazel Perkins Burnett Vernon took over the Taj Mahal. At a time when it was rare for a woman to manage property, she became friends with Kathleen Bruton, manager of the nearby El-San Apartments. Thus, Joseph Henry Burnett III (T Bone Burnett) met Stephen and Sumter Bruton, and all three hung out at the Taj Mahal's sunken pool. (Courtesy of the *Fort Worth Star-Telegram* Collection, the University of Texas at Arlington.)

THE CONTINENTAL LOUNGE
5405 CAMP BOWIE BLVD.
FORT WORTH, TEXAS

Linking the concepts of continental and metropolitan, the owners of a pair of gathering places presented one as a bar and the other, upstairs, as a non-bar. The Continental's management described it, on the back of the postcard, as a "rendezvous for Sophisticates, Celebrities, and Plain Ole Texans." (Courtesy of David Pearson.)

Ballroom dance virtuosi Eddie Deems and his wife, Lavonia Bellah, owned and managed the Lavonia Bellah dance school at two locations along Camp Bowie Boulevard for several decades. Here, Deems demonstrates a step with fellow instructor Miss Huston inside the studio. They opened their first studio downtown in 1939. Eddie and Lavonia taught at two Camp Bowie locations—5103 from 1955 to 1964 and 3801 for the rest of their shared career. (Courtesy of Eddie Deems.)

Musicians led a rock service in the basement of Arlington Heights United Methodist Church in the 1970s. Marty Burkhart and Topper Sowden were technical coordinators, and the following people played: Larry Roquemore, lead singer and saxophone; Larry Slater, lead guitarist; Gary Owens, bass guitar; Charlie Bassham, drums; and Jamie Sutton, guitar. Sowden recalled, "I may have played guitar on a few songs. Jamie's dad was minister for many years. We played at one other church, trying to get religion into progressive music. I guess it worked. Great memories. The last song was 'Jesus is Just All Right.'" (Courtesy of the *Fort Worth Star-Telegram* Collection, the University of Texas at Arlington.)

Evelyn Cromwell, at right, assists a Mott's customer in the sewing notions department in 1980—about 40 years after the five-and-ten-cent variety store opened at the western end of the first Zeloski row. (Courtesy of the *Dallas Morning News*.)

Rockyfeller's Hamburger System No. 22 at 4015 Camp Bowie Boulevard came to Arlington Heights in 1937, one of four installed in Fort Worth, founder Robert M. Chesney's town. Five years after Christina Patoski photographed the lady behind the counter in 1982, the tiny diner closed, was sold, and traveled out to a spot in Pelican Bay near the shores of Eagle Mountain Lake. It changed hands several times, and the next-to-last owner said in 2013 that it was believed to be "somewhere in Arkansas." It was the all-night source for cheap burgers with "Rocky Sauce," small anecdotes, and legends. (Courtesy of Christina Patoski.)

Joey Jett rolled in from Illinois on a train in 1977, recently discharged from the Navy after several weeks in boot camp. Christina Patoski interviewed and photographed the flamboyant, air guitar-wielding, flower-selling star of the southwest corner of Camp Bowie Boulevard and Hulen Street for a *Fort Worth Weekly* feature in April 1996. He sold flowers for the Sunshine Flower Company from 1978 until 1991, went to California because of a job offer, and returned in 1993 to resume the performance art with his own flower company. Responding to the journalist's questions about short- and long-term desires, he talked of wishing to be an on-air comedian, wanting to provide more for his family, and "to live my life to the fullest." (Courtesy of Christina Patoski.)

Blossom's opened as a live music venue and a place to wine and dine at the southwest corner of Camp Bowie Boulevard and Merrick Street in the 1980s. Occupying both the upstairs and downstairs of a hilltop building, it looked familiar to the hundreds of students who had learned ballroom dancing in Brice Evans's studio there in earlier decades. Coleman Smith (left) and Michael Malone were among the musicians who performed at Blossom's. (Courtesy of Coleman W. Smith.)

Henry Valentine Jr. built a trio of linked shotgun garage apartments at 4462–4466 Camp Bowie Boulevard in 1937. One of the last tenants, artist Danny Owens, recalled his stay: "I lived with my cat, Little Bit, at the Valentine Apartments in 1995 and again in 1999–2000. As a struggling artist, I was pleased to help keep up the property and patch the roof for cheap rent. How cool it was to be living almost rent-free in an old structure built in the '30s. . . . I was able to quietly sit and think and work on my paintings in the luxury of simplicity." (Courtesy of Danny Owens.)

Five

Perennial Centennial
A Zone of Muses and Museums

Amon Carter in 1935 . . . stared through the show window of the Newhouse Galleries in New York. Astonished, he saw with unbelieving eyes a Frederic Remington painting of an event he realized had once happened in the heat and dust of old Texas. The effect was salutary. Despite a Depression economy, he bought his first work of art on the cuff, for he did not have the cash. Amon surrendered to the Muse at 57th and Madison Avenue, though it must be noted that it was on his own strict terms; loyalty to Frederic Remington and Charles M. Russell, alone and forever, period. In two decades, Mr. Carter assembled one of the great collections of the work of his favorites.

—Mitchell A. Wilder
West Comes East: Frontier Painting and Sculpture from the Amon Carter Museum

In the same year as his Remington epiphany, the Fort Worth Star-Telegram publisher Amon Carter initiated a project that would transform fallow fields on the West Side into the venue for an extravaganza calculated to lure patrons away from the official Texas Centennial in the rival city of Dallas. The Native American cowboy comedian and pundit Will Rogers, a friend of Carter's, perished in an airplane crash in Alaska while the project was under way; the center became a memorial to Rogers. New Deal laborers constructed a coliseum, an auditorium, and a central tower, all designed by Wyatt Hedrick.

Van Zandt Jarvis, a rancher, attorney, former mayor, and son of Klehber M. Van Zandt, had arranged for the city to purchase a tract of land that had been among his father's many holdings and to use that tract for the purpose of creating exhibition and performance space. He collaborated with Carter to permanently relocate the annual rodeo and stock show from the North Side stockyards and packinghouse zone to the West Side but died before it came to be.

Museums would open near the Will Rogers complex beginning in the 1950s. A short-lived but beloved coffeehouse brought authentic espresso and bohemian hipsters to the boulevard. A small, independent hotel's subterranean after-hours nightclub offered a descent into the wild. Donald P. Dow, founder of Dow Art Galleries in 1935, was displaced three times by changes downtown; in 1969, he sold his collection of antique firearms in order to purchase a property of his own across from the Carter and its plaza. His wife, Betty Ruck Dow, and their sons worked in the gallery. "This is our tiny, tiny American dream," Gregory Dow, his son, summed up the move to 3330 Camp Bowie Boulevard. William and Pam Campbell of Wm. Campbell Contemporary Art opened their first gallery further west, at 4600 Camp Bowie, in 1974; four years later, they introduced Fort Worth's Gallery Night, which became a town-crossing, twice-yearly celebration coordinated by the Fort Worth Art Dealers' Association.

In the 78 years since local movers and shakers envisioned a place to put on a show, the presence of performers, patrons, and entrepreneurs created something greater than the sum of its parts. Framers of new urban jargon named it the Cultural District.

The Van Zandt tract south of Camp Bowie Boulevard, between Burleson and Montgomery Streets, had hosted an auxiliary remount depot, an amusement park for soldiers, and other elements of the military cantonment during the years of US involvement in World War I. When the Army packed up its tents, the tall grasses resumed their growth. Construction crews and their machines prepared to change all that in 1935. (Courtesy of the Lewis Fox Collection, Local History and Genealogy Unit, Fort Worth Public Library.)

Vehicles coming from Camp Bowie to the south approach the new Will Rogers Memorial Coliseum on the day of its dedication. For more than three decades, people could see the sweep of the memorial complex from most vantage points along the boulevard. (Courtesy of the Lewis Fox Collection, Local History and Genealogy Unit, Fort Worth Public Library.)

Friends Will Rogers (left) and Amon Carter attended a Democratic Convention. Following Rogers's death in an airplane crash near Nome, Alaska, Carter initiated the renaming of the coliseum. Carter would travel to Washington more than once to lobby for various Fort Worth causes, including help with the funding and construction of the Will Rogers Memorial Center. (Courtesy of the Amon Carter Museum of American Art.)

Van Zandt Jarvis, grandson of Isaac Van Zandt, persisted in his effort to convince the city to support the purchase of a tract of family farmland. Jarvis sought private and public support for developing the land into a performance and livestock show venue. As told by Clay Reynolds in his book A Hundred Years of Heroes: A History of the Southwestern Exposition and Livestock Show, Jarvis "played his trump card" in his campaign to bring the city's North Side to the West Side. He announced, "We have already obtained options on approximately 140 acres on Camp Bowie Boulevard . . . to erect one of the finest exposition plants in the nation." (Courtesy of Dalton Hoffman.)

What better way to lure Texas Centennial partygoers from the official Dallas site to Fort Worth than to transmit visions of provocative cowgirls and the not-so-subtle promise of a nude ranch? Fort Worth's Frontier Fiesta was not to be tamed. (Courtesy of Dalton Hoffman.)

Visitors to the Will Rogers Center discovered a custom-tailored campus with multiple attractions. (Courtesy of the Fort Worth Museum of Science and History and the Southwestern Stock Show and Rodeo.)

Dancer Sally Rand choreographed scenes that would have required ratings to be posted in a later era. (Courtesy of the Lewis Fox Collection, Local History and Genealogy Unit, Fort Worth Public Library.)

To avoid legal problems, hosts of the Nude Ranch performances handed guests small sketchpads and pencils as they entered so that the event would be considered equivalent to a studio art class. (Courtesy of the Local History and Genealogy Unit, Fort Worth Public Library.)

Although the stock show and rodeo had been suspended for one of the war years, it resumed in a big way in 1944, the year of its official and permanent location to the West Side. (Courtesy of the Fort Worth Museum of Science and History and the Fort Worth Stock Show and Rodeo.)

The midway and other elements of the North Side celebration transferred to the new site. More structures became necessary, and they were added in subsequent years. (Courtesy of the Lewis Fox Collection, Local History and Genealogy Unit, Fort Worth Public Library.)

The Renfro Drug Store chain highlighted its Camp Bowie location in this advertisement within the official program for the 1933 stock show and rodeo. Arthur "Tex" Renfro and his wife, Josephine Matthews Renfro, represented a link to the past: Josephine's father had been an officer in the Fort Worth Livestock Exchange and had purchased a large acreage in Arlington Heights in the early 1900s. He intended the land for a home on (then) Arlington Heights Boulevard and for a purebred hog farm closer to the river. (Courtesy of the Fort Worth Museum of Science and History and the Fort Worth Stock Show and Rodeo.)

The Town and Country Motel's matchbook covers depicted the plight of a cowboy out of his element in temporary lodgings at 3520 Camp Bowie Boulevard, perhaps while attending the stock show. (Collection of author.)

Fat Stock Show Visitors Are Always Welcome at Renfro's

22 Modern, Up-to-the Minute Drug Stores In Fort Worth, Decatur and Mineral Wells.

Your closest Renfro store to the Fat Stock Show is located at 3204 Camp Bowie, just two blocks away.

Visit us there for lunch, dinner, fountain refreshments or drug and toiletries needs of all kinds. Open 8 A. M. to 10 P. M. daily — 10 A. M. to 8 P. M. Sundays.

Renfro Rexall Drug Stores are in Business for YOUR Health!

SERVING Fort Worth For OVER 40 Years

RENFRO

HOME-OWNED DRUG STORES

"THERE'S ONE IN YOUR NEIGHBORHOOD"

★ 72

BREAKFAST IN BED! ...at The TOWN and COUNTRY Motel

81

At the north spoke of the wagon-wheel intersection of Camp Bowie Boulevard, Montgomery Street, Lancaster Avenue, Clarke Avenue, Bertrose Street, and Tulsa Way stood the Colonial Hotel and Apartments, which opened just a year or two before the 1944 stock show and rodeo. Owners Wyatt and Pearl Webb Slaughter had already had the experience of catering to Centennial performers at their nearby Dorothy Lane Courts. Predecessors had operated Frontier Café in the basement in 1936. The Colonial began as a genteel, small, nicely furnished place. Earlier, Web Maddox had operated one of his ice and food markets in the main building, and his word for the establishment, "Icerteria," made it into an H.L. Mencken book on such oddities. Prior to the Slaughters' makeover, it had also housed a real estate office and served as apartments. The group of buildings was standing as early as 1927. (Courtesy of Wyatt and Shelia Webb.)

Prolific artist Josephine Vaughn Mahaffey carried a portable easel in her car, according to art historian Scott Grant Barker. "If she saw a scene around town that she liked," he wrote, "she'd stop and paint it on the spot. Later, in her studio, she might rework it into a more finished image. . . . In the case of the Colonial Hotel, I'm sure it was the elaborate architecture of the place that attracted her. It stood out. It was an imposing building and a challenging subject." She and the hotel's co-owner, Pearl Webb Slaughter, were of the same generation, and both came to Fort Worth from Sulphur Springs in Hopkins County. (Collection of the author.)

In this 1952 photograph, siblings Peggy George (left), Sylvia Belle George (center), and Wayne George (second from right) pass the time with neighbor children at the Colonial Hotel and Apartments on the Montgomery Street side of the small complex. Wyatt Webb, another child then living in the complex, was a nephew of the Slaughters; his father managed the coffee shop. (Courtesy of Sylvia Belle George Walls.)

A 1960 aerial photograph shows the mid-century modern Trinity Lutheran Church (left) at the convergence of Camp Bowie Boulevard, Montgomery Street, Tulsa Way, Clarke Avenue, and Bertrose Street. The curvilinear structure replaced the congregation's earlier home, a Spanish Colonial–style former branch of a funeral parlor. The declining Colonial Hotel and Apartments, two service stations, and a supermarket also figure in this bird's-eye view. The photograph was taken prior to the building of the Amon Carter Museum of Western Art, the Colonial's fire and demolition, and the dramatic growth of the osteopathic hospital and college. (Courtesy of the Texas Department of Transportation.)

Smiley's

FORT WORTH'S FINEST AND LARGEST MINIATURE GOLF COURSE

James Earl Smiley - Doyle O. Goodwin

Coolest and Most Beautiful Spot in Fort Worth

"A Nice Place for Nice People"

CAMP BOWIE AT 7TH. ST.

Intersection of Camp Bowie and West Seventh Street

2-0936

When it comes your time to entertain why not be host here? All your guests would enjoy "Fort Worth's Great Summer Tonic."

On hot Summer days try invigorating, cool, afternoon play under our huge shade trees.

SMILEY'S
Fort Worth's Smart Drive-In Cafe
3101 Camp Bowie Blvd.

James Earl Smiley's place, atop a hill that would later be covered by wartime workers' housing units (the Parkview Apartments) and still later by the Tadao Ando–designed Modern Art Museum of Fort Worth, was a magnet by night and day. For a time, it also featured a miniature golf course. Enthusiasm for Smiley's reached beyond the provincial; its demise rated a story, "Sherman Was Not Kidding, Ft. Worth Spot Owner Finds" for *Billboard* magazine's July 3, 1943, issue. The story stated, "The war has dealt a knockout punch to Smiley's Drive-In, one of the largest and most popular eat-drink places here. Wreckers are razing the building on government orders to make way for a federal housing project originated for military plant workers. There is no suitable building for the drive-in, a dandy coin machine spot, to move to." Wartime food, drink, and employee shortages; enlistment of Smiley's business partner, Doyle Goodwin, into the Coast Guard and of Smiley into the Army; and the alliance of federal housing authorities, private contractors, and a chamber of commerce wartime housing committee meant that "Smiley's didn't take the count without real punishment." The story ended with a wistful hope: "Maybe there'll be another Smiley's when the war is won." (Photograph courtesy of the Lewis Fox Photography Collection, Local History and Genealogy Unit, Fort Worth Public Library; postcard courtesy of Dalton Hoffman; brochure from collection of the author.)

Built over Smiley's former turf for war workers crowding into Fort Worth for jobs at Consolidated Vultee (popularly called the bomber plant) and related industries, the Parkview Apartments covered most of the 3100 block of Camp Bowie Boulevard on the south side. Construction was completed in 1944, with no frills; one early resident told friends about her rough-cement bathtub. Mary Louise Phillips, a chamber of commerce official who also supervised the Fort Worth War Housing Center, coordinated with National Housing Agency representatives to address the local housing crisis. Across the street and one block west, at 3212 Camp Bowie Boulevard, a Luby's Cafeteria opened in 1946, touting in a local magazine ad its "home cooked food at popular prices prepared by women cooks." (From *This Month in Fort Worth*, June 1944, courtesy of the Fort Worth Chamber of Commerce and Local History and Genealogy Unit, Fort Worth Public Library)

After the war, new tenants who did not necessarily work in the defense industry filled vacancies in the complex. Architectural intern Douglas Wixson and his wife made their Parkview apartment newsworthy with eclectic decor, featuring a butterfly chair, mobile, leafless branch, cactus root, handmade furnishings, and an abstract painting. (Courtesy of the *Fort Worth Star-Telegram* Collection, the University of Texas at Arlington.)

Corrigan Properties, Inc., opened the Loring Hotel—fifth of its suburban hotels—in 1949 at the southeast corner of Camp Bowie Boulevard and University Drive. Called Hotel Loring by some locals because of the word order on its prominent sign, it was part of Dallas realtor Leo F. Corrigan's expanding property universe, which would eventually reach beyond Texas and the United States. *Dallas Morning News* writer Paul Crume, in one of his "Big D" columns, shared what Leo Corrigan Jr. told him: that the names of all the chain's neighborhood hotels began with the letter L, to make ordering initialed linens simpler. Colonial Golf Tournament players and Casa Mañana stars numbered among guests during the Loring's heyday, but by 1982, when photographer Ron Ennis captured some bittersweet scenes there, it was a residential hotel serving retirees. (All, courtesy of the *Fort Worth Star-Telegram* Collection, the University of Texas at Arlington.)

86

Floodwaters climbed from the Clear Fork across the old Van Zandt additions to the intersection of Camp Bowie Boulevard, University Drive, Bailey Avenue, and West Seventh Street in 1949. Neighbors who had small boats in their backyards and garages used them to rescue trapped, frightened, and stranded people. (Courtesy of the *Fort Worth Star-Telegram* Collection, the University of Texas at Arlington.)

Like its fraternal twin on the near South Side, the Renfro Drug Company No. /Alexander-Bales building carried ornate details that distinguished it from plainer commercial buildings along Camp Bowie Boulevard. It was built in the late 1920s. (Courtesy of Dalton Hoffman.)

"The Black Beret," recalled historian Lonn Taylor, "was the coffee house that Dink Starns and his business partner Louis Page operated in Fort Worth in 1959 and 1960, and during its short life it provided a tantalizing reflection of Greenwich Village to culture-hungry West Texans." Into their rented space on Camp Bowie, they brought an Italian espresso machine, waiters in white jackets, and class. Black Beret habitués included artists, an opera singer, and TCU students. "Bror Utter was my first customer," Starns recalled, summing up the first cup of espresso the artist ordered at the Black Beret. "He comes in, sits down—his glasses so thick they looked like opals—He looks up—and says, 'You're supposed to have a twist of lemon with it.'" (Courtesy of Dink Starns.)

Fort Worth Circle artists (who bonded in the 1930s) partied at the Black Beret and other venues, including the home of Flora Blanc Reeder and Dixon Reeder. From left to right are Flora, Dixon, Bror Utter, and Zane Irwin. (Courtesy of the Amon Carter Museum of American Art Archive, Virginia Camden Collection of Bror Utter Papers.)

Henry Moore visits his trio of sculptures in its new home, the eastern edge of the plaza of the Amon Carter Museum of Western Art (now Amon Carter Museum of American Art) on the day of its installation. The first of the great art museums to open in Fort Worth, the Carter began as a home for an individual's collection of works by Frederic Remington and Charles Marion Russell, but its progression toward a broader collecting and educational purpose began with the purchase of Upright Motive No. 1: Glenkiln Cross, Upright Motive No. 2 1955–56, and Upright Motive No. 7 1955–56. Of his series, Moore wrote that in the process of creating vertical works to balance a horizontal environment, he had experimented with stacking. "I started balancing different forms one above the other," he said in 1965, "with results rather like the North-West American totem poles, but as I continued the attempt gained more unity, also perhaps more organic." (Courtesy of the Amon Carter Museum of American Art.)

Frederic Remington's *Coming Through the Rye*—regarded as the artist's most popular multifigure bronze—awaited visitors to the Carter on opening day in 1961. Heroic-sized versions, cast in plaster, had been exhibited at the 1904 St. Louis Exposition and the 1905 Lewis and Clark Exposition in Oregon. The will of Amon G. Carter addressed the issue of a repository for his Remingtons and Russells: "I desire and direct that this museum be operated as a non-profit artistic enterprise for the benefit of the public and to aid in the promotion of cultural spirit in the city of Fort Worth and vicinity, and particularly, to stimulate the artistic imagination among young people residing there." (Courtesy of the Amon Carter Museum of American Art.)

Amon Carter's children, Amon G. Carter Jr. and Ruth Carter Johnson (later Stevenson), greet Phillip Johnson (left) at Carter Field, Greater Southwest Airport, on the eve of the museum's opening. The architect's role in the evolution of the museum would continue for 40 years, through two expansions. The most recent, completed in ____, was the final project of Johnson's career. (Courtesy of the Amon Carter Museum of American Art.)

Georgia O'Keeffe visited the Amon Carter Museum only once—in March 1966—for the exhibition of her work. She stands before her work *Above the Clouds IV*, one of several pieces that had to be rolled and restretched upon her arrival, requiring that she touch up the work after it was hung. (Courtesy of the Amon Carter Museum of American Art.)

One of a series of patriotic exhibitions held at the Carter leading to and through the 1976 Bicentennial, the Stripes and Stars: American Flags from the Mastai Collecton went on view in October 1973. (Courtesy of the Amon Carter Museum of American Art.)

The main (west) facade of the Kimbell Art Museum consists of three 100-foot bays, each fronted by an open, barrel-vaulted portico. (Courtesy of the Kimbell Art Museum.)

Velma and Kay Kimbell, benefactors of the museum, left their fortune for the creation of the museum. (Courtesy of the Kimbell Art Museum.)

Architect Louis Kahn stands near the light in the museum's auditorium It was the last work he would see to completion and is said to be the apotheosis of his ideas on the union of light and structure. He turned the museum over to the Kimbell Art Foundation on August 3, 1972. (Courtesy of the Kimbell Art Museum.)

Kahn desgned the Kimbell's conservation studio with a north-facing glass wall treating paintings. (Courtesy of the Kimbell Art Museum.)

Visitors to the Kimbell study the work *Standing Oba* during the museum's inaugural year. (Courtesy of the Kimbell Art Museum.)

Free festivals and spring break drop-in activities at the Kimbell have resulted in original artworks and memories. (Courtesy of the Kimbell Art Museum.)

Self-taught architect Tadao Ando, winner of the Pritzker Prize in 1995, designed the Modern Art Museum of Fort Worth, a five-pavilion complex with a reflecting pond lapping at some of the edges. He stands before the water and the structure prior to the museum's opening on December 14, 2002. The Modern's new home, just completed, stood atop a green, steeply sloping hill at the southwest corner of University Drive and Camp Bowie Boulevard 110 years after its predecessor was chartered as a library/art gallery. (Photograph by David Woo, courtesy of the Modern Art Museum of Fort Worth.)

Camp Bowie Boulevard (lower right corner) forms the northern boundary of the Modern's campus. (Photograph by David Woo; courtesy of the Modern Art Museum of Fort Worth.)

Sculptor Roxy Paine's *Conjoined*—interactive treeforms—arc and reflect during a concert over the reflecting pond. (Photograph by David Woo, courtesy of the Modern Art Museum of Fort Worth.)

Lost Country performs during the Modern's Bands Off Land concert. Local musicians played on a temporary stage reaching out over the water that laps against the north and east walls of the Modern. From left to right, John David Allen, Jeff Gutcheon, Jim Colegrove, Steven Springer, Susan Colegrove, and David McMillan perform at the 2004 event. Music had brought Ohio native Jim Colegrove to Fort Worth, and his life in music has included performances with Bob Dylan, Ian and Sylvia, and Stephen Bruton and appearances in the 2003 documentary *Festival Express*. He was a founding member of Little Whisper and the Rumors and the Juke Jumpers. The Colegroves serve on the staff at the Modern, and McMillan is a staff member at the Kimbell. (Photograph by David Woo; courtesy of the Modern Art Museum of Fort Worth.)

Six

Ridglea Has Everything
The Next Grand Plan

> *"Sooner or Later You too will take to the Hills"*
> *for twenty years we've seen them come WEST*
> *to WESTOVER HILLS*
> *to CRESTWOOD*
> *to RIVERVIEW ESTATES*
> *. . . and NOW*
> *it's RIDGLEA for better living*
>
> —A.C. Luther Realty Co.
> *Fort Worth Star-Telegram* display advertisement
> Sunday, October 30, 1948

The younger generation of Tennessee-born cotton broker Neil Publicipio Anderson's family included two men who envisioned a tony new suburb west of Arlington Heights. In 1928, Neil's son, Bernie Letcher Anderson, and his son-in-law, Morris Berney, collaborated to form real estate and construction companies and to launch what would become Ridglea to the north and south of the road extending west beyond Camp Bowie Boulevard.

In that same decade, another Tennessean, farm equipment dealer Arlie Clayton Luther, also became interested in real estate. While working in Florida, he had met two men involved in the construction of a new enclave for Fort Worth's very rich, Westover Hills. Luther came to Fort Worth, worked on Westover's further development, and paid $400 an acre for a few miles of pastureland west of Arlington Heights.

Eventually, Luther and his brother, J.T. Luther, would build Ridglea Village, a Mediterranean complex combining commercial and residential structures, in the late 1940s. The City of Fort Worth annexed Ridglea and Ridglea Village in 1944. Camp Bowie Boulevard's name reached a bit further to reflect the inclusion.

The African American community of Lake Como got caught between Arlington Heights and Ridglea in a Jim Crow dilemma, and although many of its residents worked in homes and establishments within those adjacent white neighborhoods, the logistics of getting from place to place changed. Streets that should have gone farther east from Como into Ridglea dead-ended into Guilford Road, with the back wall of the Ridglea Country Club Apartments' carports further sealing off access. For several years, an undignified alternative was to crawl through a hole in the apartments' wall and fence barricade. The barrier remained in place for decades.

Two mid-century marvels enhanced the Ridglea section of Camp Bowie Boulevard. Opening to fanfare in 1951, the Ridglea Theater became the crown jewel of the village. Then, in 1955, Houston architect Karl Kamrath topped a ridge with a Frank Lloyd Wright–inspired landmark home for the Commercial Standard Insurance Company.

Modest shelters awaited travelers who ventured west from Arlington Heights. W.T. Casstevens managed the site, Cottage City. Before the souvenir postcards were printed, a much larger Cottage City image hung in the establishment's office. In comparing past and present scenes, the contrast with the Ridglea Theater that occupied the territory in 1951 is dramatic. (Courtesy of Dan Smith.)

Ridglea developers envisioned a designed and landscaped utopia, but as late as 1937, youths from nearby Arlington Heights indicated that they enjoyed motoring out to a certain hangout in the area. Whether it was the proper name or a generic term, some Stripling High School students sketched out their journey and shared it in the school yearbook. An unknown artist produced this image for the *Yellow Jacket* yearbook in 1937. (Courtesy of Billy W. Sills Center for Archives, Fort Worth Independent School District.)

98

The Fort Worth Tourist Lodge awaited motorists at the boundary between Ridglea and Arlington Heights. In some postcard views, it appears to have been whitewashed. (Courtesy of David Pearson.)

Marjorie Johnson Reid grew up at the Rockway Courts. T.J. Johnson, her grandfather, built it in the early 1920s, and her father, Vernon, later managed the 20-cabin enclave that also featured a restaurant and service station. Behind the property, the small World War I–era Jubilee Flying Field extended east. (Courtesy of Quentin McGown.)

Z. Boaz, whose parents brought him and his siblings from the Jackson Purchase area of southwestern Kentucky in the 19th century, prospered as a rancher, investor, and owner of a large service station, garage, and country store. His wife, Teck Bishop Boaz, was a native of Tennessee. (Courtesy of Olive Greenwald.)

Situated at the Y-shaped intersection known as the Camp Bowie Split, Z. Boaz's Country Place greeted travelers on the horizon in 1929 as they contemplated going to Granbury by way of Benbrook or going to Weatherford. (Courtesy of the Texas Department of Transportation.)

As travel by automobiles and the transport of materials and livestock by trucks became more common, the need for a smoother road leading west through Ridglea and beyond toward Weatherford became acute. To grade the road in 1929, crews had to tear it up first. The state's task was to excavate for the brick paving of a pair of 24-foot strips with an esplanade between. This would match the paved boulevard to the east. (Courtesy of the Texas Department of Transportation.)

In 1928, Z. and Teck Boaz donated two large parcels of land to the City of Fort Worth for use by the public. The one bordering on Camp Bowie Boulevard became a golf course. John Bredemus designed the original course, which was enhanced by New Deal workmanship in the 1930s and closed during World War II. Byron Nelson played an exhibition match there in 1950 to promote the post-war course, redesigned by Ralph Plummer. Sports writer and novelist Dan Jenkins chose Z Boaz Golf Course for his annual Goat Hills Glory Game, a tournament featuring real-life characters from his 1965 *Sports Illustrated* story of an event at the late Worth Hills Golf Course near TCU. In its last years, Z Boaz Golf Course lost its rustic rail fence (a reminder of the Boaz ranch that preceded it) and attracted disc golf enthusiasts. The City of Fort Worth announced plans to end the golf and remake the land as a mixed-use public park. (Courtesy of the Texas Department of Transportation.)

Completed in 1941, the Bowie Boulevard Drive-In drew crowds anxious to see movies in the open air or to gain a measure of privacy on dates. Alan Sarvis's parents made him ride with his sister and her boyfriend as a preventive measure, but she and he simply let Alan wander around the grounds. Bill Trotter, who grew up in both Arlington Heights and Ridglea, described another adaptive behavior the drive-in inspired: He and his friends would pile into the trunk of the driver's car, then pop out after the driver was admitted for the price of a single ticket. The lot was wired so that sound was broadcast from underneath each vehicle. (Both, courtesy of the University of Texas at Arlington Special Collections.)

The Luther brothers and Earl Wilson commissioned Otto Phillips to design the structures and the architectural landscaping of their Mediterranean village. Phillips also designed the structures in Houston centers, the Carver Heights housing project in Dallas, and Plymouth Park in Irving. A.C. Luther contracted with Vowell Architects to create Ridglea Village during the 1940s on the north and south sides of the boulevard. Mediterranean features, including terra-cotta tile roofs and ornamental ironwork, unified the group of buildings occupying much of the 6000 and 6100 blocks of Camp Bowie Boulevard. (Courtesy of Earl Stephen Wilson and Kristilea Wilson Marks.)

A.C. Luther is pictured at left. J.T. Luther (far right) and Earl Wilson, A.C.'s son-in-law, are pictured at right. (Left, courtesy of Earl Stephen Wilson and Kristilea Wilson Marks; right, courtesy of Patsy Luther Cantrell.)

Planners of Ridglea Presbyterian Church meet in the grass-covered lot where they would build a chapel and, later, a large sanctuary and educational wing. Morris Berney had reserved a corner of Ridglea for a church, and Ridglea Presbyterian Church's board agreed to conform to the Luthers' requirement that their buildings must blend with the other Mediterranean-influenced structures of Ridglea Village. (Courtesy of Ridglea Presbyterian Church.)

Members of Ridglea Presbyterian Church worship in their chapel-in-progress on June 4, 1944. The congregation had originally met in a Ridglea storefront, with "fluorescent lights our only luxury," as one member recalled. (Courtesy of Ridglea Presbyterian Church.)

The Ridglea's curtain, with its curvature and sheen, dramatized the wide screen and recalled actual stages in theaters preceding the film era. (Courtesy of the University of Texas at Arlington Special Collections.)

The Ridglea Theater reflected the Mediterranean concept the Luthers had adopted for their village. It was considerably larger than neighborhood second-run houses, such as the Bowie to the east. (Courtesy of the Hoblitzelle Collection, Harry Ransom Center, the University of Texas at Austin.)

Jimmie Joe, of Canton, China, immigrated to the United States when he was 14, served in the US Army in Europe during World War II, and settled in Fort Worth, opening the Blue Star Inn with two relatives as partners. His son, How Mon (Edward) Joe, worked with him, planning and saving for the day he could bring his wife and young son over. (Courtesy of Phillip K. Joe.)

After a fire, the Blue Star was rebuilt with one change in its name in 1963. There was valet parking, and the new menus included steaks. (Courtesy of the *Fort Worth Star-Telegram* Collection, the University of Texas at Arlington.)

At left, family members gather at the Hong Kong airport on February 22, 1958, as mother and child headed for the United States. From left to right are Mrs George Wong, Tak Hing (Mabel) Joe (Phillip's mother), Steve Joe, Phillip K. Joe, and George Joe. Tak Hing's husband, Phillip's father, was already in the States working with his father, Jimmie Joe, at the Blue Star Inn No. 1. Airfare for Phillip from Hong Kong to San Francisco was $250. While his grandson, Phillip, and Phillip's mother were waiting for papers to be processed so that they could emigrate, Edward would provide money to one of the waitresses at the Blue Star for the mission of purchasing cowboy clothes. He would put them on, then pose for photographs to be sent back to the States. For the trip to his new home in the United States, he had to leave the horse behind. He later named his graphic design business the Cantonese Cowboy. (Both, courtesy of Phillip K. Joe.)

Prior to the sale of the Blue Star, Phillip, a graphic artist, painted a dragon along the length of the Camp Bowie Boulevard side of his family's bright-white restaurant exterior. Clashing aesthetically with the restaurant, a Dunkin' Donuts shop stood directly in front of the Chinese restaurant for several years before the property changed hands again in 1975 and the Mexican Inn group took it over. (Courtesy of Phillip K. Joe.)

107

Karl Kamrath of Houston introduced bold drama in texture and chiaroscuro onto the crest of a hill in Ridglea at 6421 Camp Bowie Boulevard. His client was the prominent and Fort Worth–centered Commercial Standard Insurance Company. Suburban legend among some current employees of firms in the building has it that it was intended to double as a Cold War bunker. This view is from the Camp Bowie Boulevard side. (Photograph by W.D. Smith, courtesy of the Alexander Architectural Archive, University of Texas at Austin.)

Kamrath's louvres filtered punishing Texas sunlight and, to continue the legend, supposedly could be adjusted and completely closed in case of disaster. (Photograph attributed to W.D. Smith, courtesy of the Alexander Architectural Archive, University of Texas at Austin.)

The Commercial Standard Insurance Company building opened on December 18, 1956, with, from left to right, Raymond Buck, Lt. Gen. Roger Ramey, USAF, Kay Buck, and Sen. Lyndon Baines Johnson making it official. Recalling the event in 2013, Raymond Buck's daughter talked of A.C. Luther's pride in witnessing the addition of a new landmark to the landscape. (Courtesy of the *Fort Worth Star-Telegram* Collection, the University of Texas at Arlington.)

The employee cafeteria featured food imported from an area restaurant. (Courtesy of the *Fort Worth Star-Telegram* Collection, the University of Texas at Arlington.)

Industrialists associated with Fort Worth's Double Seal Ring plant dreamed of creating a luxury hotel as an investment. They chose a location in Ridglea on the south side of the boulevard. (Courtesy of Patsy Luther Cantrell.)

In the branding room at Western Hills, diners could experience the branding process by searing the initials "R," "M," or "WD" into their cuts of beef. (Courtesy of Quentin McGown.)

Irene Patoski was at the helm of one of Fort Worth's most prominent travel agencies, International Travel Service, located at the Western Hills Hotel. She was active in travel professionals' organizations and travel, including for Western Airlines. A native of Greece who spoke seven languages, Irene went on to the vice presidency of Viking Travel Agency in Minneapolis, managing European operations for Marriott Corporation's executive travel division, and in 1972, she became the cruise director on Sun Lines' *Stella Solaris*. (Courtesy of Christina Patoski.)

The Patoski children, Christina and Nick, inhabited the Western Hills world during some exciting seasons, as documented in this photograph taken by their father, Victor. To accommodate the hotel's celebrity guests, including television stars Lucille Ball and Desi Arnaz, Dale Robertson, comedian Jerry Lewis, actor James Garner, country comedienne Minnie Pearl, actress Carolyn Jones, and teen heartthrob Tommy Sands, the hotel's owners built their own heliport in 1953—the first of its kind worldwide—at the southwest corner of Camp Bowie Boulevard and Edgehill Road, directly east of the hotel. Important guests were ferried between Amon Carter Airfield and Western Hills via Bell 47 helicopters. "Our mom knew when they'd be landing and had us be part of the welcoming committee," reminisced Christina. (Courtesy of Christina Patoski.)

City parks department workmen landscape portions of the boulevard's parkway in the 6300 block in April 1958. (Courtesy of the *Fort Worth Star-Telegram* Collection, the University of Texas at Arlington.)

Stanley Marcus's February 12, 1962, letter to Fort Worthians concerned the future Neiman-Marcus building on the site of the demolished Bowie Boulevard Drive-In, near the Weatherford Traffic Circle. It would be the third of nine Neiman-Marcus branch stores built between 1951 and 1976. "When the store is finished," he wrote,"we feel that it will become the pride of Fort Worth. It will be like nothing else we have ever done and probably like nothing you've ever seen. It will be of a most unusual architectural concept." Patsy Luther Cantrell, daughter of developer J.T. Luther, preserved a copy in her files. (Courtesy of Patsy Luther Cantrell.)

Bernd Shnerzinger, a native of Hamm, Germany, correctly calculated that if any military personnel at Carswell Air Force Base had previously been assigned to Germany, they would gravitate toward his restaurant on the traffic circle. Bernd juggled cooking, monitoring the dining room, and singing for the first years. Randy Souders captured Schnerzinger's multitasking ways in a caricature. (Courtesy of Bernd Schnerzinger.)

The son of a fine cook who was also a home economics teacher, Schnerzinger discovered his true calling when still young. He made his way from Hamm, Germany, to the United States and proved himself as a sous chef at a major hotel in Dallas and at the Petroleum Club in Fort Worth. He founded Edelweiss on the Weatherford Traffic Circle in 196_ with a loan from Ridglea State Bank and the guidance of Earl Wilson, son-in-law of A.C. Luther. He participated in international Escoffier societies, appeared on the Dinah Shore show, and sang, played the spoons, and "kissed 2,000 women" during his 30 years at the restaurant. (Courtesy of Bernd Schnerzinger.)

113

The R.E. Cox Department Store opened at 6370 Camp Bowie Boulevard in 1957. Recalling childhood romps through the Ridglea store, Elizabeth Howard Simmons wrote, "Working full time at the store were my grandfather, R.E. Cox, Jr.; my uncle, R. Earl Cox III; and my father, W. Elray Howard. My mother, R. Earl Cox III's sister, Carolyn Cox Howard, did not work there—she was a stay-home mom. Back in those days [of] the Blue Law, retail stores were closed on Sundays. My dad would go up there many Sunday afternoons to work, or would work after hours. We would get to take our friends to the store when it was closed, and it was like a giant playroom. Great hide-and-seek games . . . sliding down between the escalators . . .and the occasional sneaking into the candy department to partake (which we were not allowed to do)." Cox's merged with W.C. Stripling Department Stores, then closed in 2007 and was demolished in 2008. (Photograph by W.D. Smith, Courtesy of R. Earl Cox III.)

Counterculture claimed a spot facing the boulevard in the early 1970s, as demonstrated with a matchbook (left) from Tom Atkins' shop. At right, Donnie White and Craig Lidell celebrate the eggplant in the kitchen of Zeke's Fish & Chips at 5920 Curzon Avenue. "We love Zeke's longhairs," a D Magazine columnist wrote in 1983, "but the thing that keeps us coming back is the golden, crisp batter that coats almost everything Zeke's serves." HOP nightclub owner Lidell and Michael Mann bought Zeke's from its founders in 1971; White helped them get started. Through a series of buyouts, Zeke's became a family business with Craig's brother, Mark; their late father, Robert; and Mark's wife, Diane Barnes Lidell. Majority owners Mark and Diane have worked there for 42 and 28 years, respectively. (Left, courtesy of Vicki Barnes Norris; right, courtesy of Mark Lidell.)

Alan Price conducted an oldies disco at various venues along Camp Bowie Boulevard and vicinity in the 1980s and 1990s, always welcoming Mickey Mouse as the real host. Price would introduce and spin records and swing dance to oldies along with his guests. A Brooklyn native, Price had come to Fort Worth on a military assignment and soon began his long second career as a disc jockey with his program the radio station at Carswell Air Force Base in 1971. Even after hosting the last Alan's Club, he resumed sharing oldies via live streaming on the Internst from his home near Fort Worth—a show called Alan's Golden Oldies. (Courtesy of Alan Price.)

The Rio Motel had begun to decline a bit when Alan Price rented the vacant club space in the upstairs, glass-walled room overlooking the boulevard. (Courtesy of Quentin McGown.)

115

The Jackalope came to rest on a flat roof in Ridglea, but it was born in Arlington Heights in 1982. As Kay and Robert Thomas were preparing for the debut of their eclectic super-curio-shop Jackalope business on Camp Bowie Boulevard, Kay urged artist Nancy Lamb to create her version of the mythological western antler-crowned hopper. She assembled a team to help execute her design: from left to right, Adam Lamb, Russ Eddy, Nancy Lamb, and Douglas Blagg. When the property changed hands and functions, the new owner promised to leave the heroic figure to monitor comings and goings on the boulevard. (Courtesy of Nancy Lamb.)

Alyce Adair Jones (at center, underneath awning) chose a Ridglea Village location for her luxury eyewear boutique. She began the tradition of hosting a fundraiser for a different cause each year and collaborated with Fort Worth's Shakespeare in the Park nonprofit organization to draw a supportive crowd in 1993. (Courtesy of Alyce Jones.)

Seven

Renaissance and Reinvention
Reconciling Old and New

Mutantur omnia, nos et mutamur in illis.
(All things are changed, and we are changed among them.)

—Late Latin Proverb

In the late 20th and early 21st centuries, new development projects escalated in the zone between Montgomery Street and the Clear Fork along the former Arlington Heights Boulevard. These included condominium towers, mixed-use commercial and residential structures, conversion of a Montgomery Ward store into residences, and a blue-hued glass triangle housing a sushi bar.

In Ridglea, an endangered movie palace found a benefactor who believed it could live again as a house for music and more and who funded a restoration. Historic Fort Worth, Inc., raised more awareness of, and funds for, the project and hosted a gala reopening in 2012.

Susan Allen Kline's successful nomination of the theater for inclusion in the National Register of Historic Places afforded significant protection. At the terminus of what was traditionally called Camp Bowie Boulevard, the intersection with Alta Mere Drive, merchants and others succeeded in their campaign to rename the stretch of road that had long been called "Highway 80 West" to "Camp Bowie West," taking the name all the way to the area where the controversial Kuteman Cutoff (one man's idea of a safer route to Weatherford) was meant to become part of the main Bankhead Highway.

Affirming the resiliency and the humor that gets Texans through trying times, street-topper signs for Linwood, a modest post–World War II neighborhood within the old Van Zandt Addition hit hard by a tornado, carry the silhouette of a twister. Arlington Heights' new post office, designed by an internationally renowned architectural partnership, includes a mural showing storm clouds, and the bent standards of a tornado-wrenched billboard remain in the ground like sculpture. The mission of the postal carriers is printed over the depicted storm scene.

Camp Bowie District, Inc., originally named Historic Camp Bowie District, Inc., launched Jazz by the Boulevard, a community event to celebrate a genre of music and a legendary thoroughfare. The organization's administrators decided to remove the references to the boulevard and to jazz, renaming it the Fort Worth Music Festival. Poet Dave Oliphant, who spent part of his childhood in Arlington Heights, wrote "Jazz by the Boulevard" after attending one of the events; his concluding passage reads as follows: "here one block over from Camp Bowie / the brick-paved street intersects with University / where admission is gratis / thanks to Cadillac's / major financial grant & to volunteers / manning booths including that Rocky Mountain beer's / causes one to wonder does hurt & happiness accord / with the roots of a minor chord / can the melodic blend in any song / set right a lingering wrong / seems so to go by the loving-it look / when these Black men cook / with their hard-bop licks / their soulful stratospherics / a look apparent on any listener's face / regardless of race / or place of birth / due in part to an elegant auto's corporate worth / but most to elder statesmen hanging on / to produce a dateless priceless tone." (Courtesy of the Local History and Genealogy Unit, Fort Worth Public Library, and Camp Bowie District, Inc.)

The Camp Bowie District's parkway plantings and banners on the boulevard signaled to motorists that participating businesses were funding enhancing and unifying improvements. (Photograph by Brian Hutson, courtesy of Hutson Creative Group.)

Joanne Rew (later Sarsgard) joins others in an emotional push to preserve the brick pavement along Camp Bowie Boulevard. The effort succeeded. (Courtesy of the *Fort Worth Star-Telegram* Collection, the University of Texas at Arlington.)

At the start of the 21st century, Dan Smith, historian of Texas, stretch of the Bankhead Highway system, began a campaign to make residents and merchants along the old "Broadway of America" route aware of the heritage and legacy of the cross-country highway that reached Fort Worth and Camp Bowie Boulevard in the 1920s. (Courtesy of Dan Smith.)

119

Built in 1931, the commercial building facing the boulevard from 4600 Dexter Avenue was long a part of the Web Maddox empire of ice production and sales. Metamorphoses of the former Icerteria and Crystal Ice outposts began in the 1980s. Two restaurants came and went, followed by Into the Garden, an emporium of planters, fountains, furniture, and design elements for the outdoors. Vestiges of the ice making era were retained, as store personnel point out. (Photograph by the author.)

A younger generation of Texas Freemasons includes motorcyclists at the Arlington Heights lodge. One recent poker run—a charity fundraiser involving advance donations, drawing of high and low cards, and a ride to various destinations—came to its final stop at 4600 Camp Bowie Boulevard, where the hosts at Lodge No. 1184 served lunch and raised additional funds through a silent auction. "Typical of Masons in general," noted Jim Clark, "the winner of this particular ride simply signed his winnings over to the charity without hesitation; it was about $400, as I recall." (Courtesy of Jim Clark.)

Sam Austin, senior project architect with CMA, directed the massive restoration of the Ridglea Theater, where his father had been the projectionist and where he had spent many hours of childhood and beyond. The auditorium, photographed by Austin from the top of the balcony just after restoration was begun, shows various extensions, divisions, and damage done over the years and through alterations for other uses. "The ceiling was three different colors, because the balcony had been split down the middle to create two very small theaters on the upper level," Sam Austin noted. "The balcony had also been extended approximately 20-feet toward the stage." (Courtesy of Sam Austin.)

As restoration was nearly complete, the architect and craftspeople could survey the results of restoring the paint color scheme, hanging of new curtains, and other replications to match the original style. (Courtesy of Sam Austin.)

121

Metal divider strips had to be placed in the floor prior to terrazzo restoration. (Courtesy of Sam Austin.)

To restore the ornate terrazzo floor in the Ridglea's lobby, supplemental lighting was used to help assure accurate work and the best match for each of the 11 colors. Craftsmen spent several weeks sitting on the hard floor hand-grinding damaged edges to an irregular shape. Austin explained that grinding helps blend the new terrazzo mixture with the original. "By the way," he noted, "the compass rose is not aligned with the lobby walls, but actually points to true north." (Courtesy of Sam Austin.)

Nancy Lamb, the featured artist in Historic Fort Worth, Inc.'s 2012 Preservation is the Art of the City event and exhibition, and her husband, Robert Lee Powell—veteran, stockbroker, Optimist, and adventurer—celebrate the Ridglea's gala reopening in the personae of Lucille Ball and Desi Arnaz. (Photograph by Glenn Killman, courtesy of Nancy Lamb.)

A ship sails out on the west wall of the theater's lobby, a detail from the three-wall mural depicting conquistadors and pirates by the Norwegian decorative painter Eugene Gilboe. Sam Austin pointed out that, after painting the mural with ordinary house paint at the age of about 70, Gilboe was paid about $700, "which represents a VERY small percentage of the cost of restoring the work." The artist had been recruited to Texas for the embellishment of Fair Park for the Texas Centennial of 1936. (Courtesy of Glenn Killman.)

A vacant church became a sanctuary of sweets in 2011. The first secular occupant of the Arlington Heights Presbyterian Church building preserved the walls, ceiling, and altar area and began hosting small weddings and private parties after the move from the Zeloski commercial row. (Photograph by the author.)

The University of North Texas Health Science Center's evolution from a tiny, one-story osteopathic hospital on Camp Bowie Boulevard's south side in the 1950s to the facility it is today proceeded rapidly once the Texas Legislature approved recognition of osteopaths. Amon G. Carter and Sid W. Richardson, wealthy and powerful advocates for osteopathic practitioners, assured their ascendancy and helped secure prime West Side real estate prior to the state sanctioning that led, eventually, to the link with the university. (Courtesy of the University of North Texas Health Science Center.)

Philip Johnson called the Amon Carter Museum of American Art "*the* building of my career." His third and last Carter design tripled the exhibition space. It reopened, after a dramatic transformation, in 2000. (Courtesy of the Amon Carter Museum of American Art.)

Renzo Piano's selection as architect of the Kimbell Museum expansion brought to the area another international figure, charged with another formidable assignment. (Courtesy of the Kimbell Art Museum.)

Architects at the Philadelphia firm founded by Robert Venturi and Denise Scott Brown designed the understated new post office at the gateway to Arlington Heights, in a triangle where Camp Bowie Boulevard, University Drive, and Bailey Avenue intersect. Grants from local foundations and a collaboration involving Museum Place Development Group, Ltd., and the US Postal Service helped fund the building, native plantings, stormy mural, and the familiar assertion of the mail carriers' dedication. (Photograph by the author.)

"The architects spent the money on the postage," wrote architect and architectural historian Kevin Keim. In the Fort Worth set of his PlaceNotes photography card series, Keim included the new Arlington Heights post office. In accompanying text, he noted that "it was this Texas sky that spawned a tornado [in 2000] that churned menacingly close to the Kimbell and its treasures. . . . Luckily, the twister swerved and squashed a billboard instead, leaving mangled steel columns that now sculpturally stand here as four bent exclamation points punctuating nature's power." (Photograph by the author.)

Selected Bibliography

Anderson, Patrick. *Lords of the Earth*. Garden City, NY: Doubleday & Company, 1984.
Ball, Gregory W. *They Called Them Soldier Boys: A Texas Infantry Regiment in World War I*. Denton: The University of North Texas Press, 2013.
Barker, Scott Grant, and Jane Myers. *Intimate Modernism: Fort Worth Circle Artists in the 1940s*. Fort Worth: Amon Carter Museum, Texas Christian University Press, 2008.
Bates, Charles D. *Ridglea Presbyterian Church*. Fort Worth: Ridglea Presbyterian Church, 1981.
Bristow, Nancy. *Making Men Moral: Social Engineering During the Great War*. New York: NYU Press, 1996.
Brown, Gaye L., ed. *West Comes East: Frontier Painting and Sculpture from the Amon Carter Museum*. Worcester, MA: Worcester Art Museum, 1979.
The Capsule. Fort Worth: Camp Bowie Base Hospital, 1919.
Carraro, Francine. *Jerry Bywaters: A Life in Art*. Austin: The University of Texas Press, 1993.
Chastaine, Ben-Hur. *Story of the 36th*. Oklahoma City: Harlow Publishing Company, 1920.
Collins, Michael. *Those Daring Young Men: A History of the Automobile Pioneers in Fort Worth, 1902–1940*. Fort Worth: Frank Kent, 1978.
Cuellar, Carlos. *Stories from the Barrio*. Fort Worth: Texas Christian University Press, 2004.
George, Juliet. *Fort Worth's Arlington Heights*. Charleston, SC: Arcadia Publishing, 2010.
Halsell, Grace. *In Their Shoes*. Fort Worth: Texas Christian University Press, 1996.
Historic Preservation Council of Fort Worth and Tarrant County. *North Side, Westover Hills, West Side*. Fort Worth: Historic Preservation Council of Fort Worth and Tarrant County, Survey, 1988.
Houston, H.T. Warner et al., eds. *Texans and Their State: A Newspaper Reference Work*. Houston: The Texas Biographical Association, c. 1918.
Jacobs, Allan B., Elizabeth MacDonald, and Yodan Rofé. *The Boulevard Book: History, Evolution, Design of Multiway Boulevards*. Cambridge, MA: MIT Press, 2002.
Jary, William. *Camp Bowie, Fort Worth: 1917–18*. Fort Worth: B.B. Maxfield Foundation, 1975.
Jones, Jan. *Renegades, Showmen, and Angels: A Theatrical History of Fort Worth, 1873–2001*. Fort Worth: Texas Christian University Press, 2006.
Kline, Susan Allen. *Fort Worth Parks*. Charleston, SC: Arcadia Publishing, 2010.
Liles, Debbie Linsley. *Will Rogers Coliseum*. Charleston, SC: Arcadia Publishing, 2012.
McGown, Quentin. *Fort Worth in Vintage Postcards*. Charleston, SC: Arcadia Publishing, 2003.
Miller, Scott Reagan. *The Architecture of Mackie and Kamrath*. Houston: Rice University, 1993.
Pipkin, Turk. *The Old Man and the Tee: How I Took Ten Strokes Off My Game and Learned to Love Golf All Over Again*. New York: St. Martin's Press, 2004.
Seward, William F. "Leaves from a Camp Librarian's Notebook." *Library Journal* (January 1919).
Taylor, Lonn. *Texas, My Texas: Musings of the Rambling Boy*. College Station: Texas A&M University Press, 2012.
Trotter, William J., ed. *The Official Ridglea Classified Directory*. Fort Worth: W.J. Trotter & Associates, 1961 and 1962.
Tyler, Ron, ed. *The New Handbook of Texas*. Austin: Texas State Historical Association. www.tshaonline.org/handbookonline.
Wallis, Martha Hyer. *Finding My Way: A Hollywood Memoir*. New York: HarperCollins, 1990.
Williams, Joyce E. *Black Community Control: A Study of Transition in a Texas Ghetto*. New York: Praeger Publishers, 1973.
Wright, George S. *Monument for a City: Philip Johnson's Design for the Amon Carter Museum*. Fort Worth: Amon Carter Museum, 1997.

DISCOVER THOUSANDS OF LOCAL HISTORY BOOKS FEATURING MILLIONS OF VINTAGE IMAGES

Arcadia Publishing, the leading local history publisher in the United States, is committed to making history accessible and meaningful through publishing books that celebrate and preserve the heritage of America's people and places.

Find more books like this at
www.arcadiapublishing.com

Search for your hometown history, your old stomping grounds, and even your favorite sports team.

Consistent with our mission to preserve history on a local level, this book was printed in South Carolina on American-made paper and manufactured entirely in the United States. Products carrying the accredited Forest Stewardship Council (FSC) label are printed on 100 percent FSC-certified paper.

MADE IN THE USA